WORKING WOMEN

WORKING WOMEN

An Appealing Look
at the Appalling Uses and Abuses
of the Feminine Form · By Jessica Strang

Introduction by Lorraine Johnson

With 200 color photographs

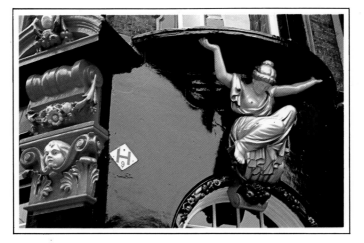

Harry N. Abrams, Inc., Publishers, New York

Produced by Johnson Editions Ltd
30 Ingham Road
London NW6 1DE
England
Designer: Lorraine Johnson
Editor: Georgina Harding

ISBN 0–8109–2284–3
Library of Congress Catalog Card Number: 84–71267

Printed and bound in Hong Kong

Photographs on the title pages:
Contemporary plastic draughtsman's aid, for
assorted instant curves, by Timesaver Tem-
plates of Dallas, Texas.

Painted lady supporting a bay window above the
doorway to the Shipwright's Arms in Tooley
Street, London SE1, close to the River Thames.

Photograph opposite:
Feminine, earthenware variation of the Toby
jug. The famous tippling figures, first made in
Staffordshire, England, in the 1760s, have been
imitated worldwide.

—CONTENTS—

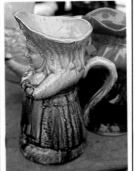

–INTRODUCTION–

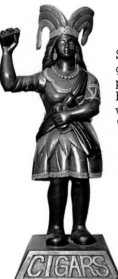

She flies from the front of the world's most expensive car, graces one of man's most coveted sporting trophies, sells products as diverse as photographic film, crackers and car batteries! No part of her is sacred – her skirts keep teapots warm, dust furniture, dispense perfume and even light up. To make matters worse, she is dissected – her lips become a sofa; her legs kick smoke, open letters, hold toast, file fingernails and – more disturbingly – crack nuts; her hands hold flowers, scratch backs and clutch golden chains. But worst of all, she is debased, crouching on all fours with a thick glass tabletop on her back.

But look again. She also supports the scales of justice and holds high the torch of liberty, symbolizing all that is noble in the human race. Every quality that "man" has ever striven for finds expression in the female form. Why is a woman made to do all these things?

Most of these WORKING WOMEN were probably conceived, designed and/or manufactured by men. Why didn't they choose to exploit the male form instead? (Interestingly, Working Men are far more rare.) Is it simply that the "opposite" sex appealed more? Is it because the female form, with its curves, is intrinsically more decorative or is there some deeper, more sinister reason for subjecting woman to such treatment? Perhaps men idolize her, try to capture and dominate her and then, sensing her power even under the yoke, try to banish their guilt by freeing her and setting her up as their ideal, creating a multiplicity of roles and tasks for her so that she does not quite escape their jurisdiction.

After a glance at the following pages (verified by noticing what is all around you), you will agree that the female form has been put to more uses than any book could ever hope to contain. The WORKING WOMAN may be kitsch or artifact, but it is amazing how often she is there.

Why WORKING WOMEN? Well, "WOMEN" because the author as a woman, feminist and photographer was overwhelmed by the ubiquity and variety of the representations of the female form, and "WORKING" because she noticed women being employed to perform rather incongruous tasks, each labor showing the woman in a new guise: a woman has worked atop the Acropolis in Athens, holding a ton of stone on her head for the last two and a half thousand years; more recently she supports a candle, a clock or a golf ball, her body stirs cocktails and lures fish to the hook.

Jessica Strang's selection is, of course, limited by the constraints imposed by the size of this book, although she took over three thousand photographs to get the two hundred here. In order to qualify for inclusion, the woman in question had to be performing some function, rather than merely being decorative.

However, the woman is always downright unnecessary to the task she performs; her feminity is quite irrelevant – a doorpull doesn't require a slender angel to facilitate the opening process; salt and pepper shakers don't have to be served by a uniformed maid. Her labors are many and varied, but in each case her presence must say something about the maker and the user.

How should women react? Should we be flattered that men choose us to adorn one of their most coveted sporting trophies or insulted because they force us into an idealized, erotic body designed to open their beer bottle? Should we maintain a sense of humor when we see Jayne Mansfield as a hot water bottle luring a sleeper to his bed, or outraged at the concept, manufacture and even inclusion in this book? Surely we cannot ignore these travesties, but should they invoke laughter or our anger? Extreme feminists may come to one conclusion about the images on the following pages, wondering how a professional woman photographer could assemble such a collection. Sexists will opt for another, more offensive interpretation, insisting that it is only natural to look at a woman's body as an object, and only a step further actually to turn it into one. Or will you reach the same conclusion that Jessica and I have, that one cannot make too serious judgements about the meaning behind a design, knowing that the creator probably had a variety of justifications for his creations.

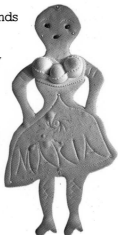

Perhaps we can only wonder at the places where men's minds go, knowing that "woman's work is never done." Whatever conclusion is reached, Jessica Strang's book has raised our consciousness. It is an eye-opener for all to see just how many everyday objects we take for granted, even when they have one overwhelming theme in common. It takes an eye like Jessica's to see and collect the WORKING WOMEN of the world. *Lorraine Johnson March, 1984*

Opposite: Romanticized American Indian woman holding cigars, of carved and painted wood, probably made in New York City circa 1880. Once a common sight outside tobacconists', these trade figures disappeared as the city's streets became more crowded.

Right: Hard biscuit made with flour and honey representing Artemis of Ephesus, the ancient goddess of fertility, and said to bring fertility to the woman whose name it bears. Similar biscuits are sold all over southern Italy and known as the "Bread of Frascati".

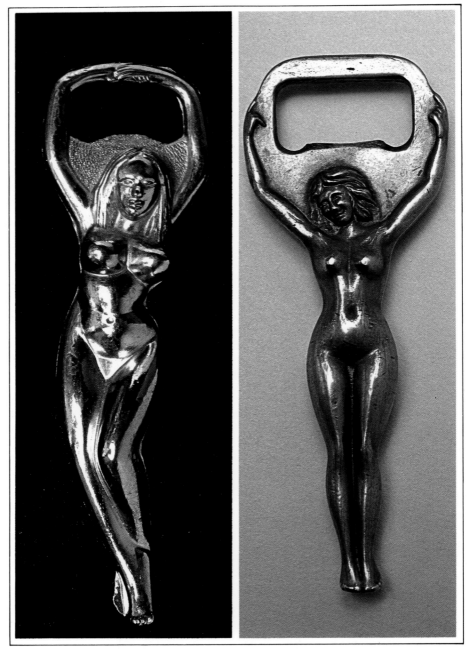

Left: Voluptuous chrome bottle opener. *Right:* A more demure nude, made of brass. In the first three openers the arms either hold or form the curved head of the crown-top opener so that it is cleverly integrated into the overall design.

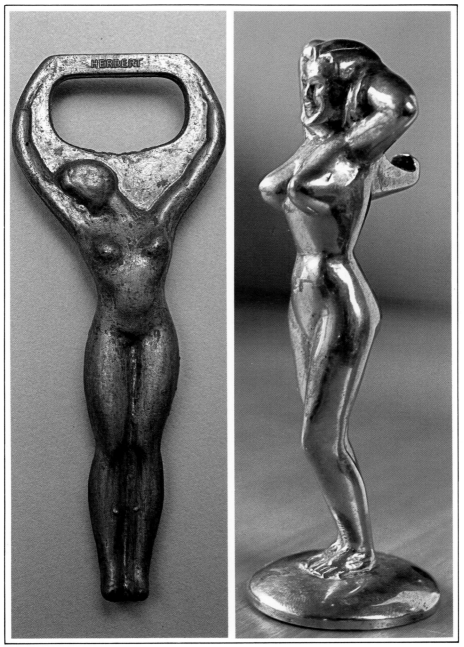

Left: Slender 1930s sylph, an aluminum opener. *Right:* A vulgar brass version from the 1960s, in which the opening device protrudes inelegantly from the woman's back.

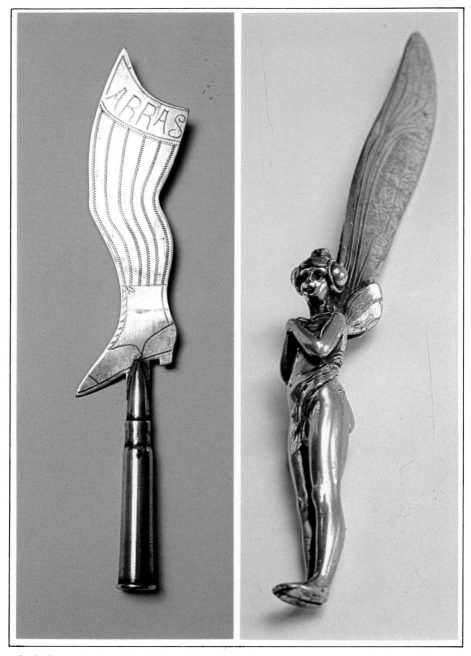

Left. Souvenir from the Battle of Arras; a letter opener made by a British soldier in France during the First World War, using a .303 rifle bullet and a scrap of brass.
Right: Whimsical letter opener from Germany some twenty years earlier, an Art Nouveau fairy whose long wings form the blade. Made of silver-plate on pewter.

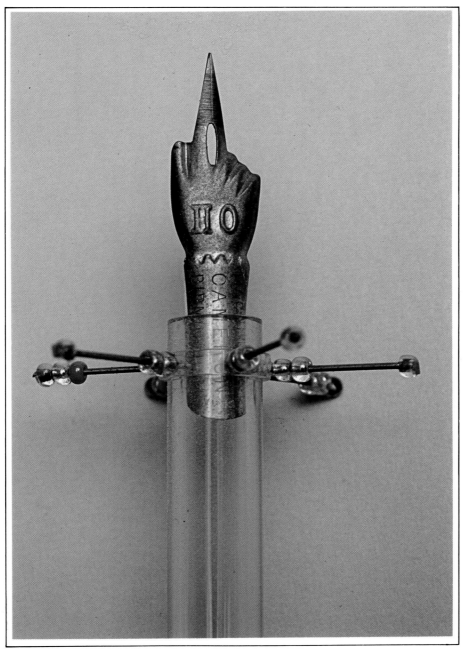

A writing hand in the form of a gilt nib surrounded by ingenious distancing device of
pins with glass beads. Made in Birmingham, England,
in 1900 by MacNiven and Cameron.

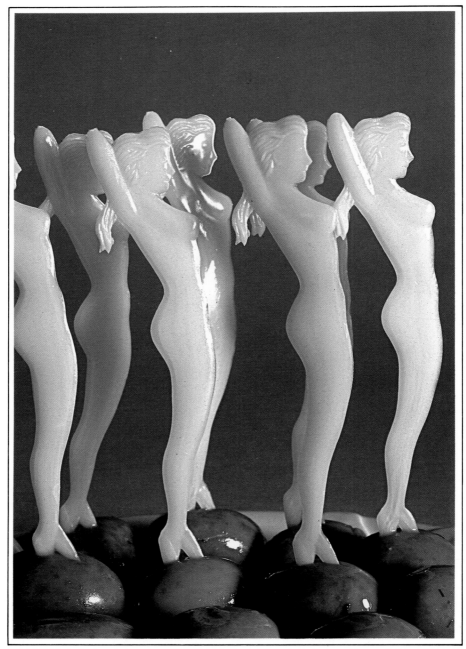

Plastic, pseudo-ivory bathing beauties with stiletto heels for stabbing cocktail olives.
Made in Hong Kong – for "gracious entertaining", the packet says.

—SWIZZLER—

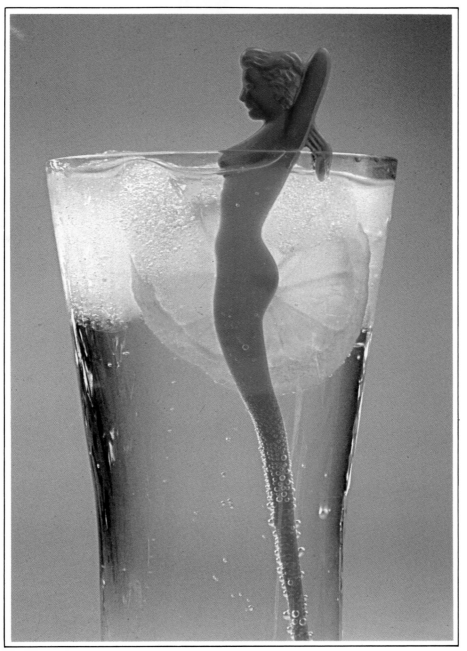

Curvaceous swizzle stick in luminous plastic – to stir a high-spirited cocktail.
Also made in Hong Kong.

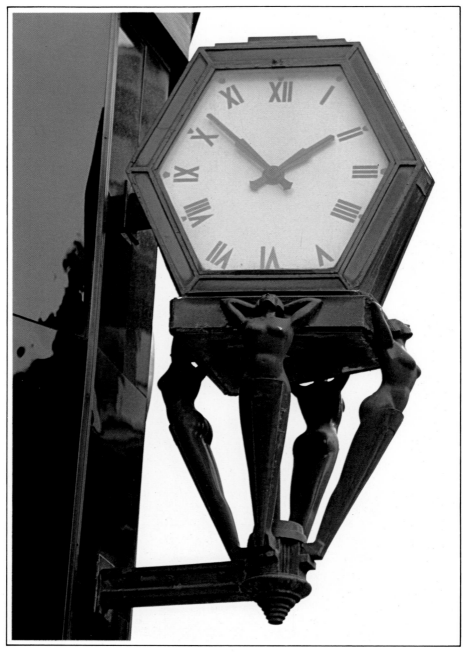

Four lithe Art Deco women, of cast iron, supporting a clock above Cambridge Circus, London WC2. The shop beneath them was once, surprisingly, a gentleman's outfitters; it is now a hamburger take-away.

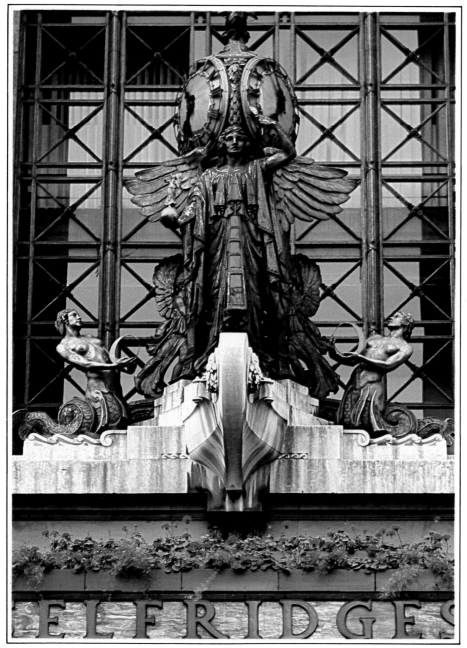

"The Queen of Time", attended by nymphs holding the waxing and waning moons (symbolizing the tides), beneath the monumental chiming clock at Selfridges department store, London W1. Cast in bronze, with gold and faience inlay, the clock was conceived by the architect A. D. Millar, sculpted by Gilbert Bayes and installed in 1931.

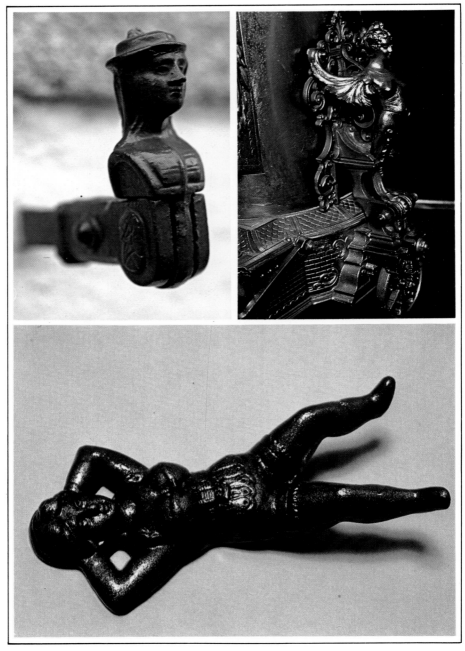

Top left: Bolt on the window shutters of a house in Le Faouët, Brittany. *Top right:* Ornate folding hob, one of a pair flanking a freestanding wood-burning stove by Société Choubersky, made in Paris, 1870. *Bottom:* Reproduction bootjack aptly called "Naughty Nellie", depicting a Victorian circus rider.

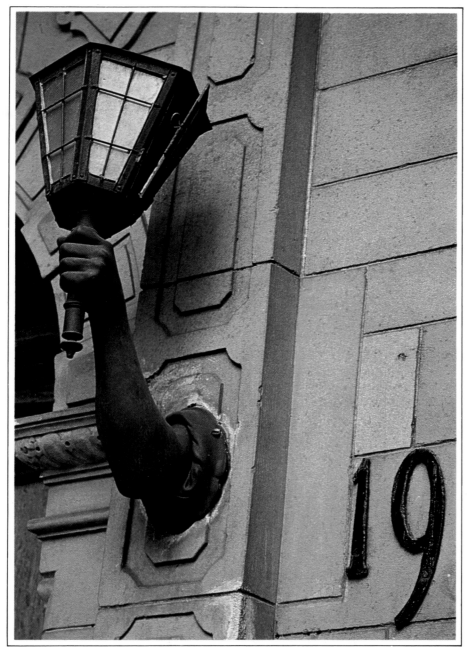

Surreal, life-size cast iron woman's arm holding a lamp at an entrance in Cadogan Place, London SW1. Sadly, it has recently been removed.

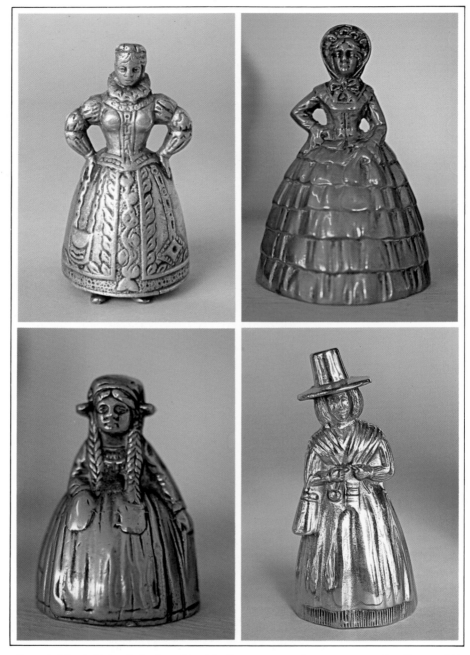

From left to right, top to bottom: Hand-bells to summon the servants, made of brass. Old bells in the form of a Tudor housewife (whose boots form the clanger), a Victorian lady and a Dutch girl; modern reproduction bell showing a Welsh woman in national dress.

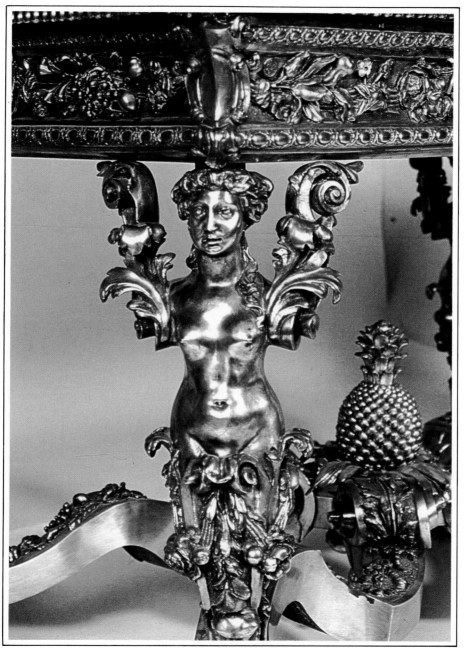

Table-leg in the form of a winged woman, from an electrotype copy of a silver pier table in the collection of Her Majesty the Queen at Windsor Castle. The original was made in London in 1700 by Andrew Moore.

—BATHING BELLES—

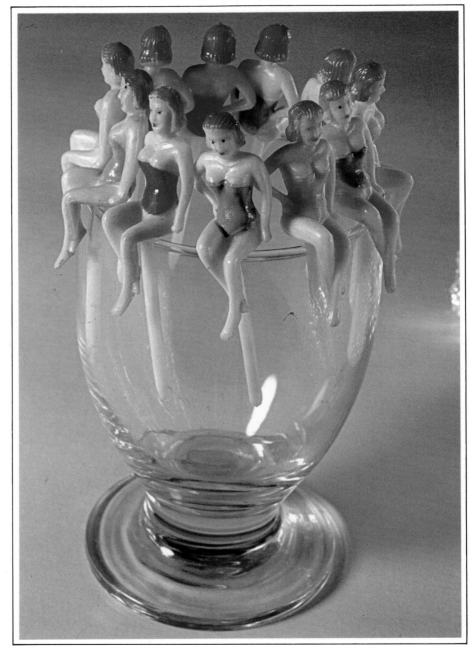

A bevy of waterside beauties to top your drink. Contemporary cocktail sticks in crudely hand-painted plastic, made in Hong Kong.

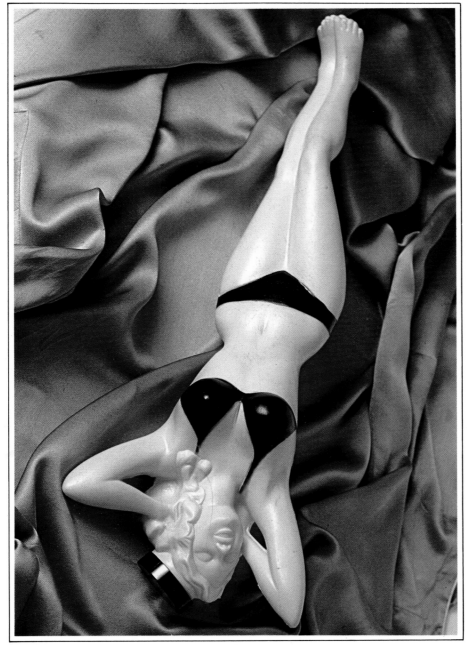

Bed warmer in the shapely form of Jayne Mansfield. She is plastic, 22 inches long, and her pillbox hat unscrews so that she can be filled with hot water. Made in 1957 by Poynter Productions, Cincinnati, Ohio.

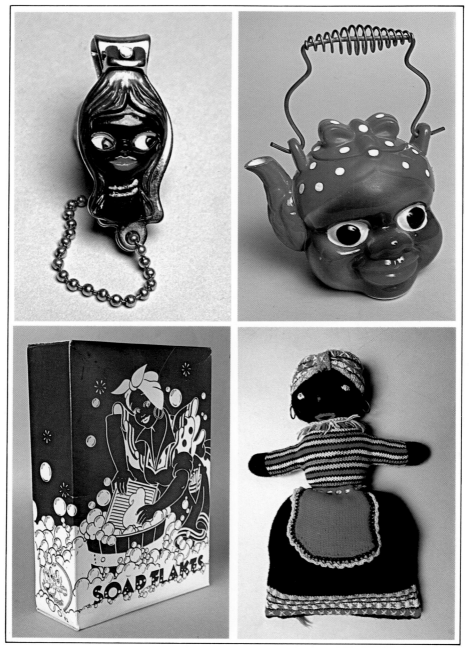

From left to right, top to bottom: Modern nail-clippers (a punk wig replacing the traditional bandana); nineteenth-century Japanese teapot, with glazed finish but hand-painted turban; soap-flakes packet designed for Biba, the 1960s London boutique that became a stylish department store in the early 1970s; knitted pyjama-case from South Africa.

—BLACK WOMEN—

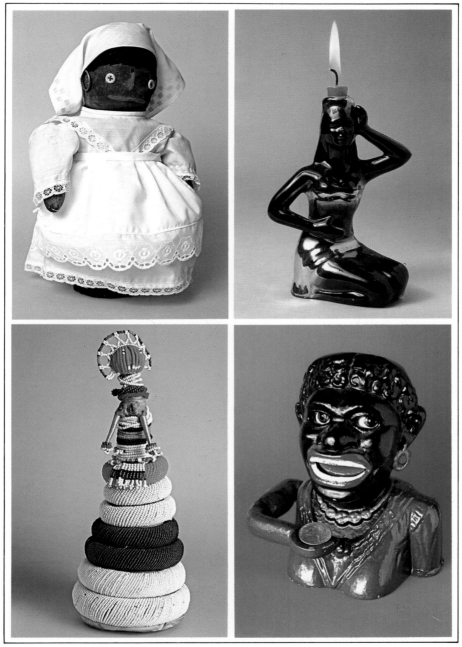

From left to right, top to bottom: Doorstop made out of a weighted bottle, from South Africa in the early 1940s (the original clothing now replaced with baby clothes); contemporary Italian candlestick; doll doorstop from Mapoch village in South Africa, made by people of the Ndebele using their traditional bead-and-wire jewellery; American moneybox, "Dinah", circa 1880 (her eyes roll when the coin drops into her mouth).

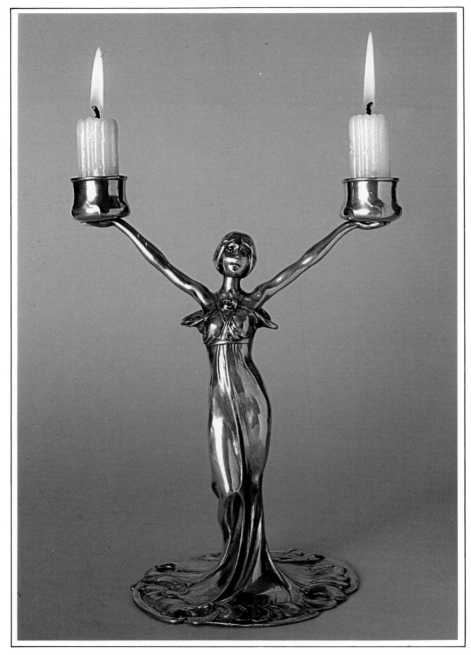

Art Nouveau lady, her arms outstretched to support two candles, the hem of her dress decorated with swirling mistletoe motif characteristic of the period. Pewter, probably made in Germany circa 1900.

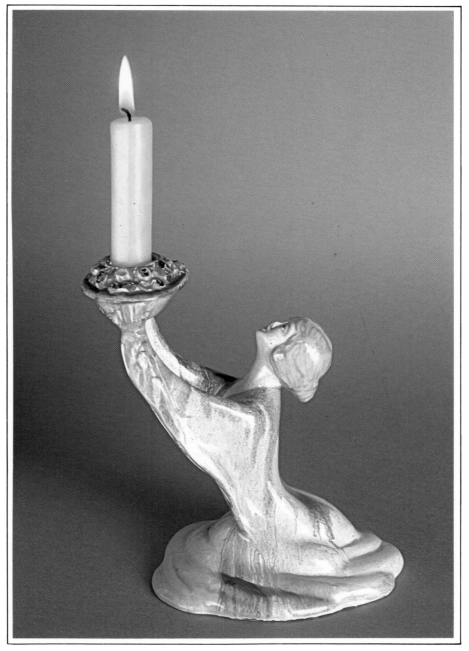

Kneeling woman holding a candle, a hand-painted ceramic candlestick. Made as part of a limited edition by Clarice Cliff in 1932.

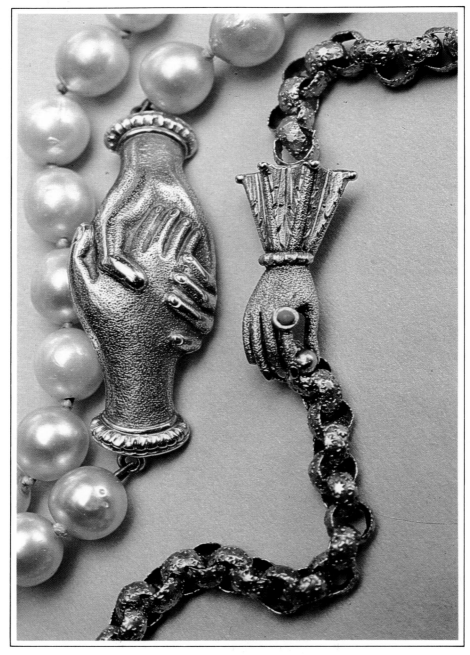

Two gold hands forming an appropriate clasp on a pearl necklace, and a single gold
hand, complete with a turquoise ring and a frilled cuff,
fastening an early Georgian gold chain.

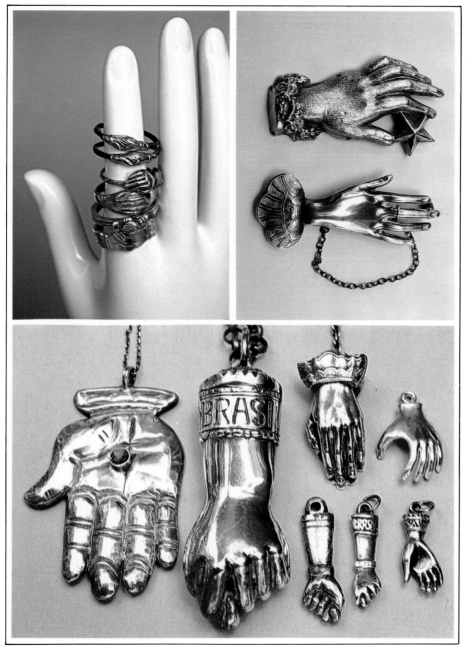

Top left: Friendship rings, including two made of gold and elephant hair, from India, and an early Irish design in which the hands open to reveal a heart (second from bottom). *Top right:* Silver-plated reproduction Regency brooch of a hand holding a star, and a silver brooch from India. *Bottom:* Silver pendants and charms; the hand with the turquoise comes from Mexico, the clenched fists with protruding thumbs (symbolizing fertility) from Brazil.

—KNOCKERS—

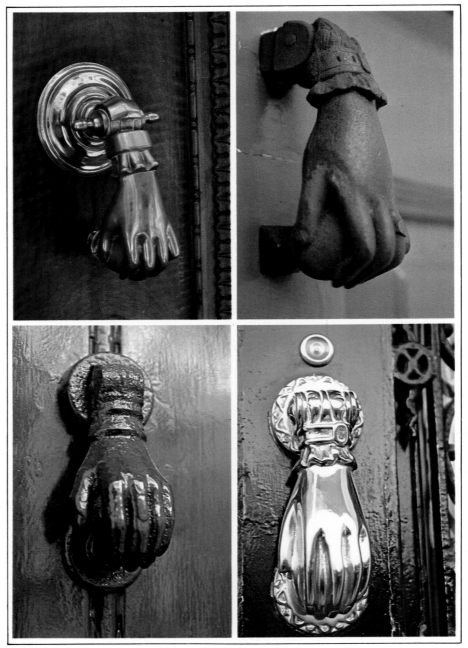

From left to right, top to bottom: Door knockers made of brass or cast iron offer a welcoming handshake in the South of France; in Sicily; in Holland Park and Knightsbridge, London. (The last, a Victorian design, is still available from the original supplier, Beardmore's, in London.)

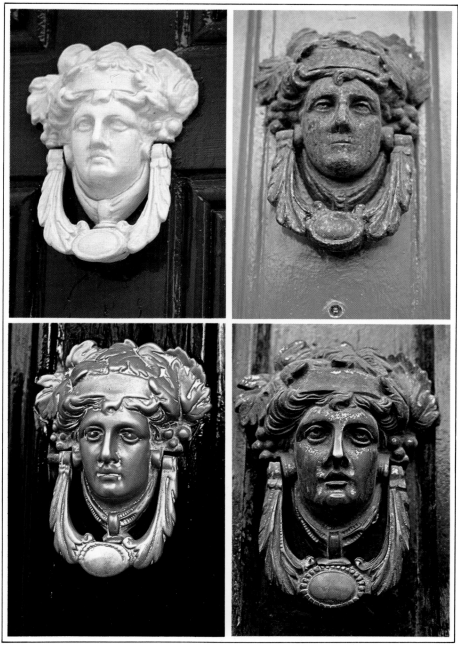

From left to right, top to bottom: The heads of neo-Classical matrons give an imposing appearance to four London thresholds. Foundries all over England made variations of this fashionable Victorian design, in which a flowing "necklace" forms the knocker, an ornate collar the base-plate.

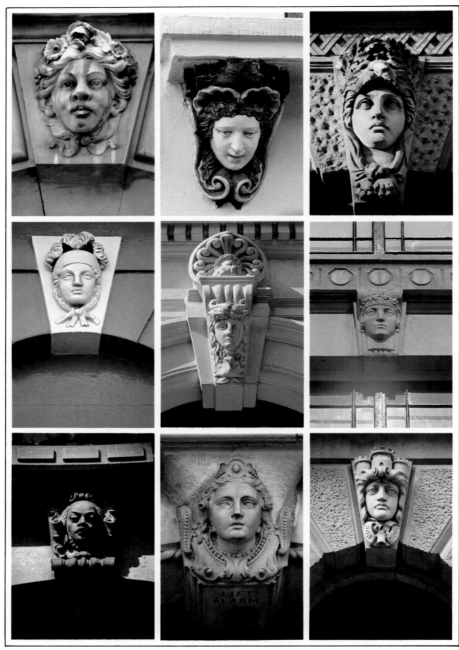

From left to right, top to bottom: European corbels and keystones at the former Sunderland House, once the home of Consuelo Vanderbilt, in Curzon Street, London W1; at the Ballet Rambert School, Pembridge Road, London W11; at the Geological Society, Piccadilly, London W1; in Camberwell, London SE5; at the Wellington Club, London SW1; at 86 Portland Place, London W1; at the Theatre Carré, Amsterdam; on High Holborn, London WC1; at the Bank of Scotland in Threadneedle Street, London EC2.

—KEY SUPPORTS—

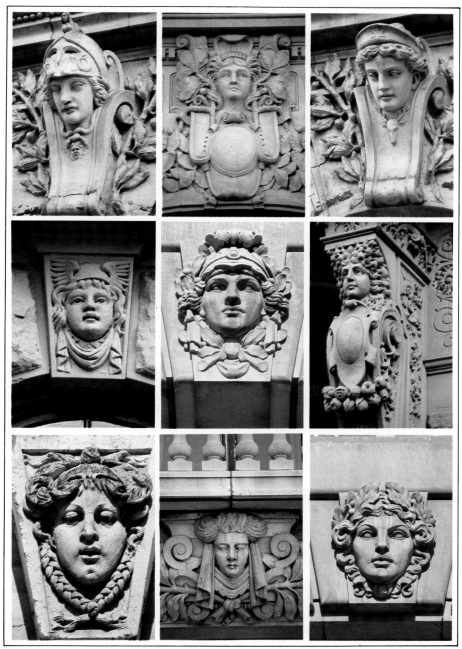

From left to right, top to bottom: American corbels and keystones at the Old Lyric Theater, West 42nd Street, New York; at 131 Riverside Drive, New York; also at the Old Lyric Theater; in Soho, New York; on Constitution Avenue NW, Washington DC; at 42 Morton Street, New York; from a demolished New York building, now in the sculpture gardens of the Brooklyn Museum; at the Coliseum apartments on Riverside Drive; also on Constitution Avenue NW.

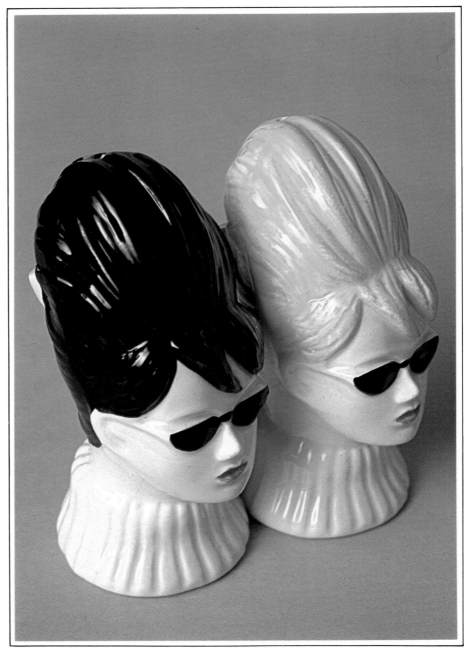

Salt-and-pepper set made as a send-up of the 1950s "beehive" hair-style, by Swineside Ceramics, England. The blonde one holds salt, the black-haired one, pepper.

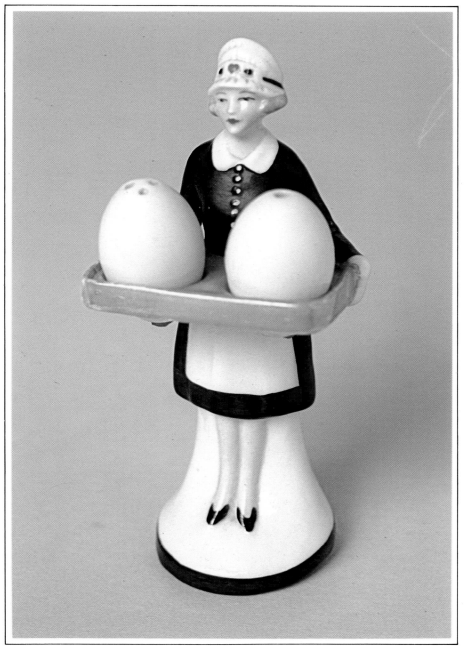

Forever at your service, with salt and pepper on a tray!
German ceramic cruet from the 1920s.

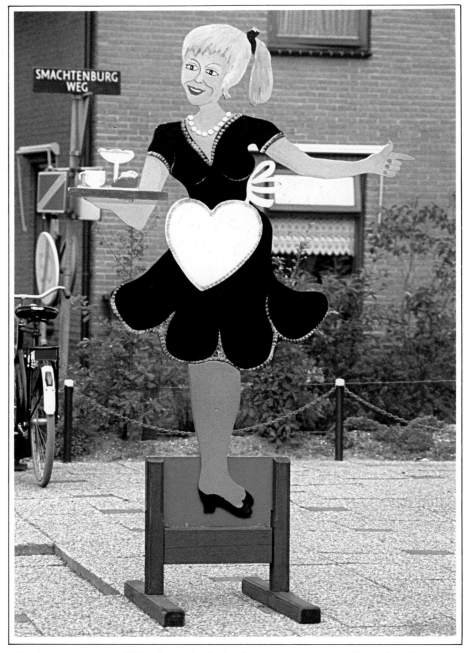

A cut-out waitress in 1960s dress displaying her wares on a tray. Naive, hand-painted sign tempts customers into a café in a Dutch village.

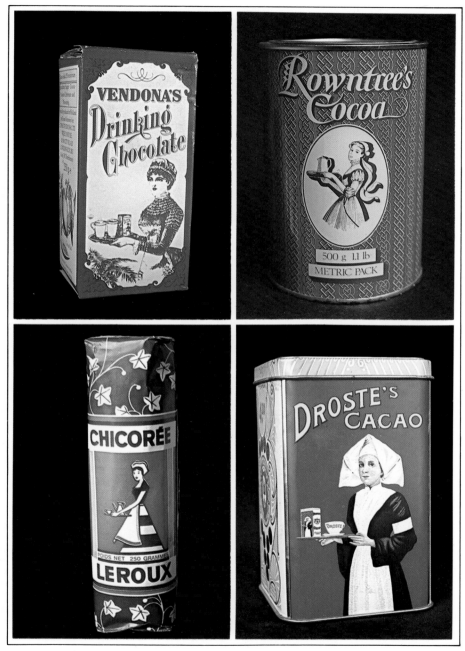

From left to right, top to bottom: Nostalgic packaging. A Victorian maid on a new brand of English drinking chocolate; "White Rose of York", Rowntree's 1891 cocoa girl, reproduced on their new metric pack; an aproned waitress from the 1930s on a French packet of chicory; the homely Dutch woman pictured on Droste's cocoa tins ever since 1898.

Betel-nut cutter, brass with an iron blade, made in Sri Lanka in 1982. The design, characteristic of the region, depicts a woman with her hands joined in a traditional gesture of greeting.

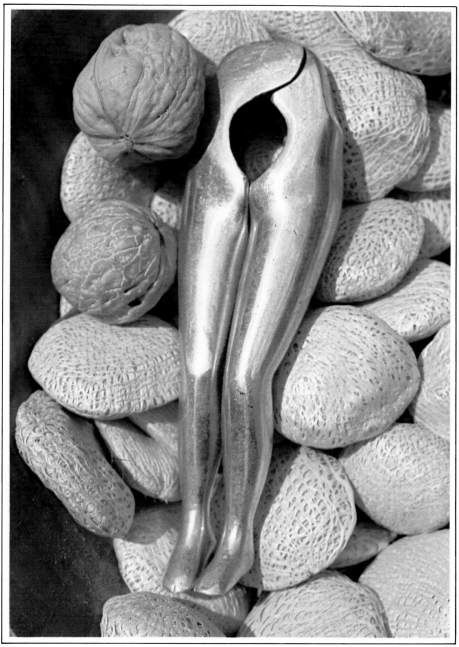

Brass nutcrackers, made in Birmingham, England, in the 1930s, from a Victorian design. In practice, their form facilitates their function, as the curved legs are easy to grip.

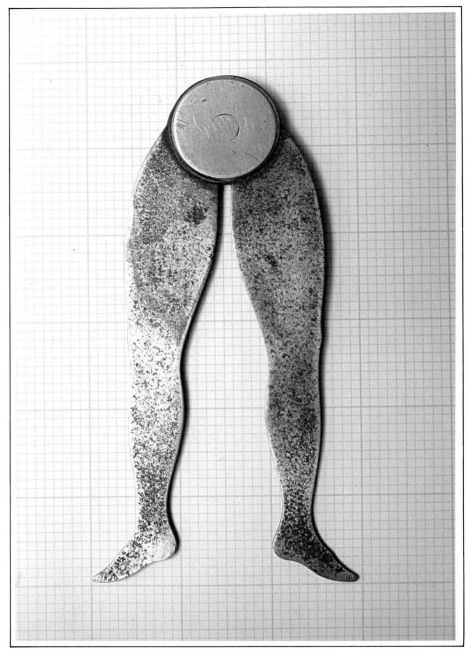

Late Victorian calipers, made of steel – to measure vital statistics?
They were probably an apprentice's sample.

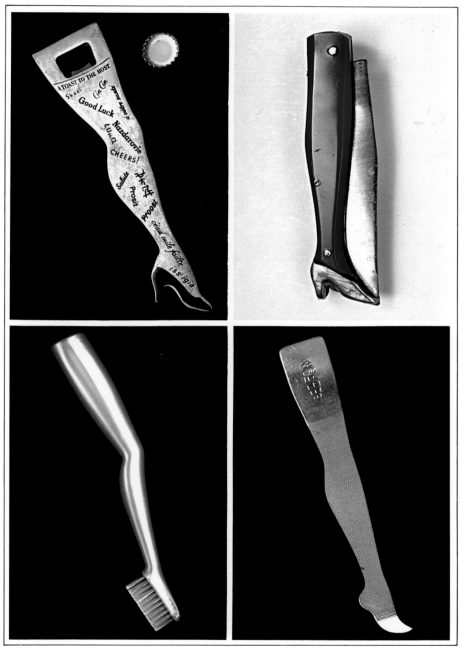

From left to right, top to bottom: 1950s Italian bottle opener with toasts in many languages written on the leg; penknife with a red plastic stocking and brass shoe to shield the blade, probably Victorian; contemporary opalescent pink plastic toothbrush, made in Japan; nail-file made in England in the 1970s (the engraved stocking mesh forms the filing surface).

—CLEANING LADIES—

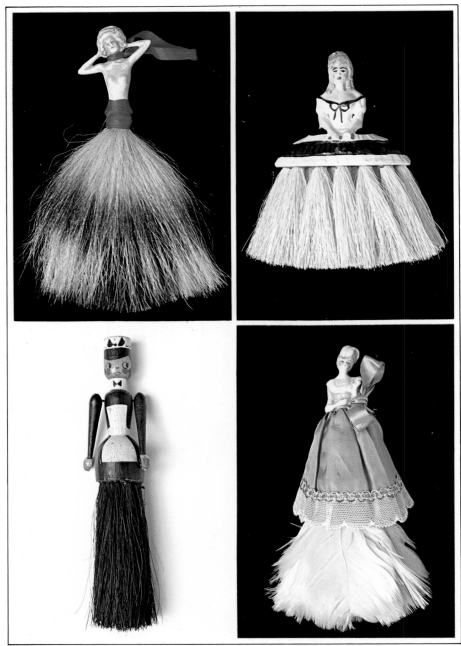

From left to right, top to bottom: For the lightest dusting, a delicate brush of porcelain
and squirrel hair; for crumbs, a ceramic Little Bo Peep (made as a fairground prize) and
a painted wooden parlourmaid; for the dressing table, a feather duster with a porcelain
handle covered in satin and lace.

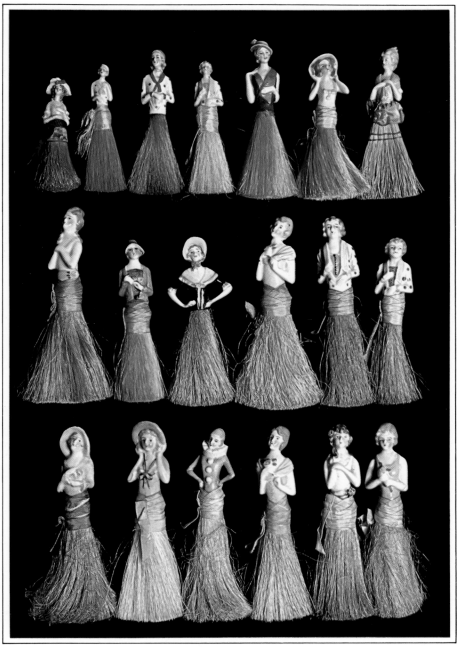

A collection of fine crumb brushes, bought over many years in London's Portobello Road market. Each one is different, yet each has a hand-painted porcelain bodice, and a bristle-skirt tied or fitted to suit the fashion.

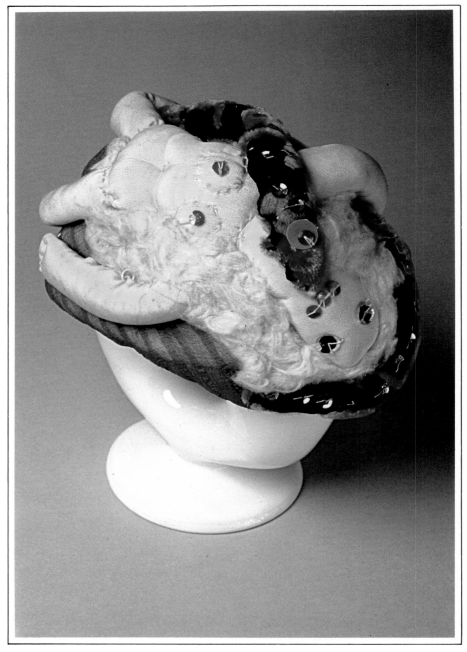

Cosy for two eggs by English sculptress Polly Hope, 1983, made of padded and patched pieces of fabric. "Eve and the Serpent" offer breakfast temptation.

—COSY LADIES—

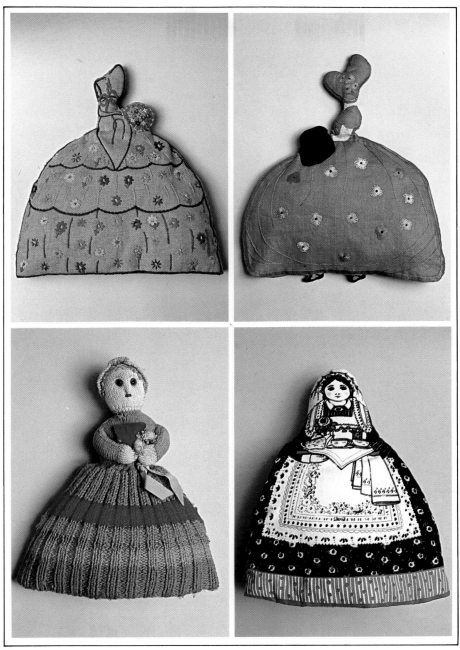

From left to right, top to bottom: Tea cosies with padded skirts to hold the heat. Two bonnetted Victorian ladies, hand-embroidered in the 1920s or 1930s; a hand-knitted cosy with a ribbed skirt from the 1940s; "Mrs. Rose", a modern silk-screened version.

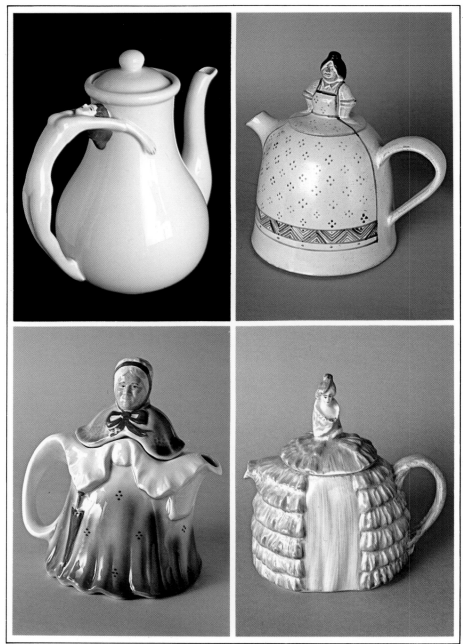

From left to right, top to bottom: Four images of women on English teapots. A sinuous nude; a buxom farmer's wife; an old Victorian lady (her voluminous shawl ingeniously incorporated into the spout and handle); a lady in a crinoline, called "Daintee Laydee", made in the 1930s.

—TEE LADY—

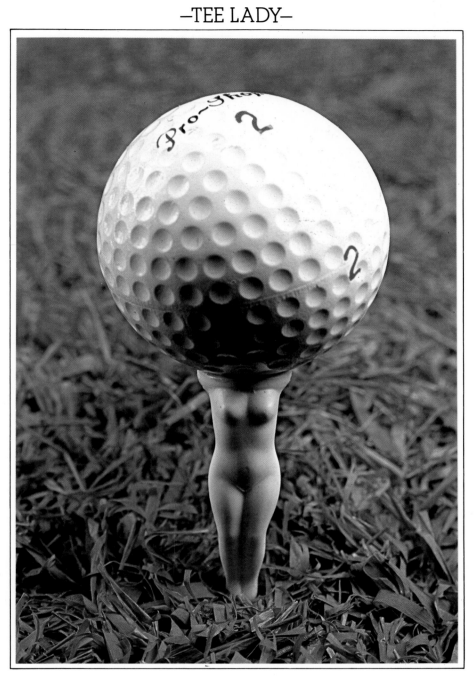

White plastic golf tee in the shape of a woman, made by J. B. Halley in St. Andrews, Scotland, the home of the Royal and Ancient Golf Club.

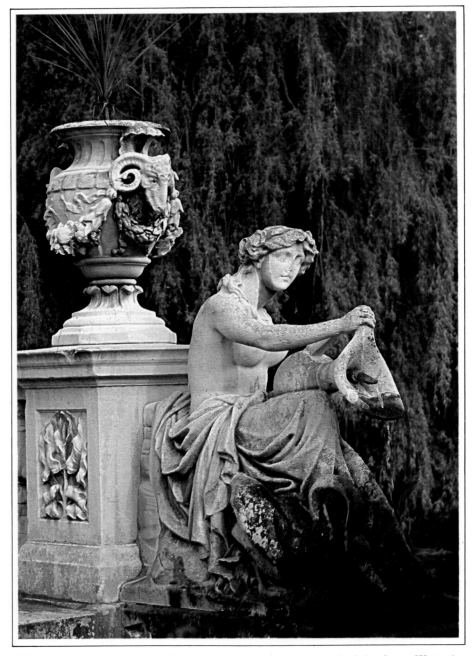

Water-bearer, part of the Italianate fountain at the north end of the Long Water in Kensington Gardens, London. The Long Water was commissioned by Queen Caroline for the royal park, which was first opened to the public in 1726.

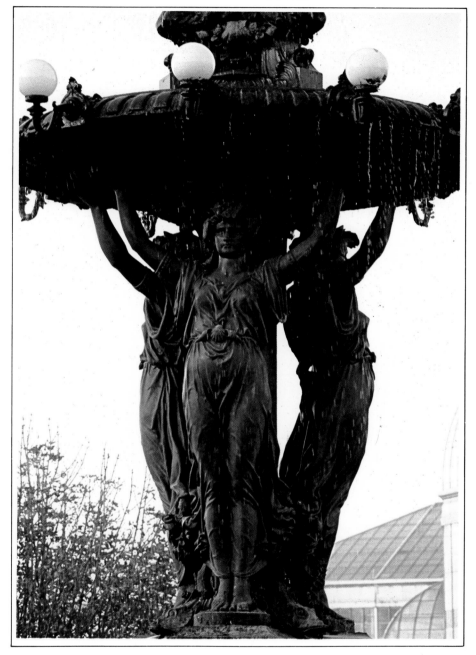

The centrepiece of the Bartholdi Fountain at Independence Avenue and First Street SW, Washington DC: three amazonian bronze caryatids carrying a wide basin, from which hang twelve Victorian electric lamps. The fountain was cast in Paris, exhibited at the Philadelphia Centennial Exhibition of 1876, then brought to Washington, where its display of electric light drew many visitors.

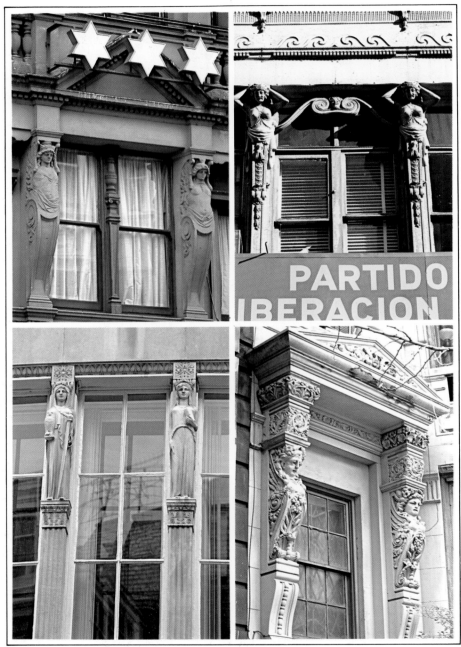

From left to right, top to bottom: Caryatids flanking the windows of the London Hippodrome in Cranbourne Street, WC2, built in the ornate Loire style, 1900; offices on 146th Street and Broadway in Spanish Harlem, New York, built in 1912; 44 Hallam Street, London W1, built in 1915 for the General Medical Council (the figures represent classical deities concerned with medicine); 315 West 103rd Street, New York, grandly refurbished in 1891.

—WINDOW WOMEN—

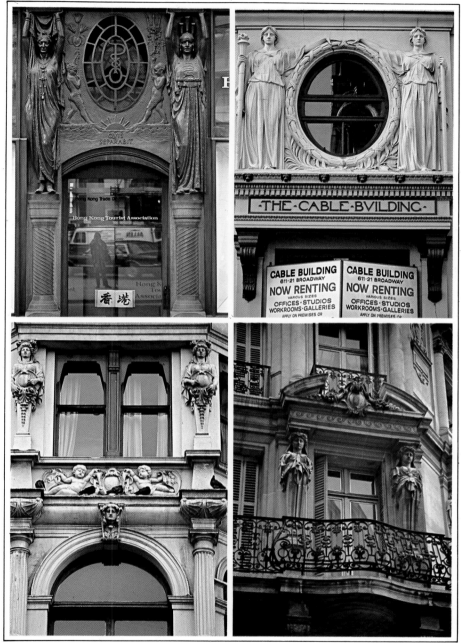

From left to right, top to bottom: Ornate figures at the Peninsular and Oriental Line's 1907 building in Cockspur Street; London SW1; the 1894 Cable Building on Broadway, New York; Queens House, a late Victorian commercial building in Leicester Square, London WC2; nineteenth-century apartments in the fashionable Seventh Arondissement, Paris.

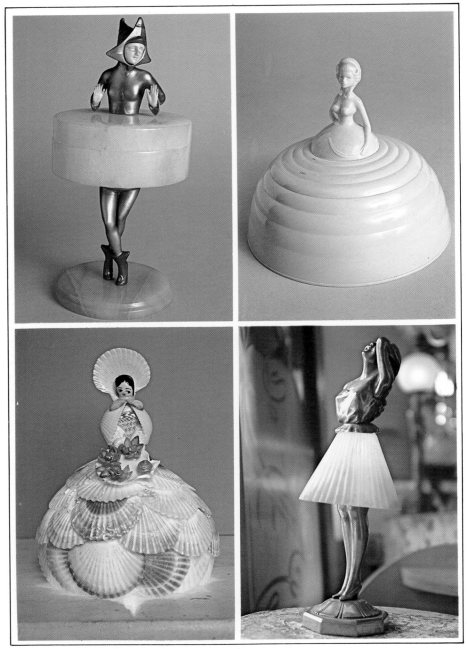

From left to right, top to bottom: Late 1920s powder box (the pixie is exquisitely detailed though she's made of inexpensive plastic and alabaster instead of ivory and marble); 1950s English powder box, made of plastic; a lamp from the Philippines, made entirely of shells; a modern copy of a 1930s French lamp.

Art Deco dancer who exudes perfume as well as light. Light glows through her pale skin, and through the flowers in her hands and on her skirt; the perfume essence or oil, stored inside the figure, is warmed by the heat of the light bulb so that it rises and wafts through fine holes in the bouquet. Made for Brule Parfums, Paris.

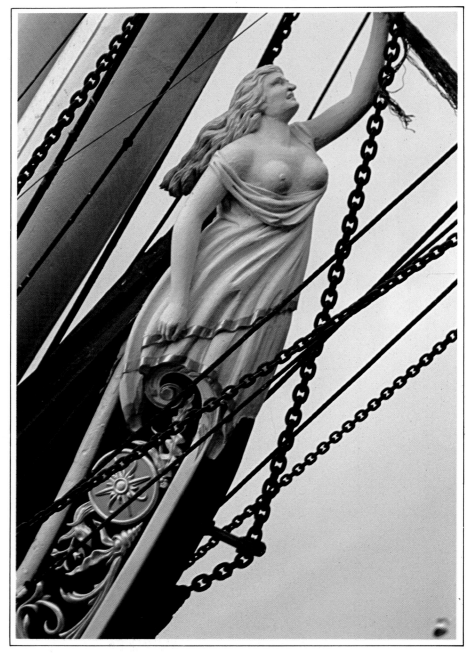

Figurehead of the clipper, the *Cutty Sark,* built at Dumbarton, Scotland, in 1869, and now, at Greenwich, London. She represents Nannie, the witch dressed in a "cutty sark" (short shirt) who snatched the tail from Tam O'Shanter's horse in Robert Burns' famous poem. Her white-and-gold dress signifies that she sailed distant trade routes.

—FIGUREHEADS—

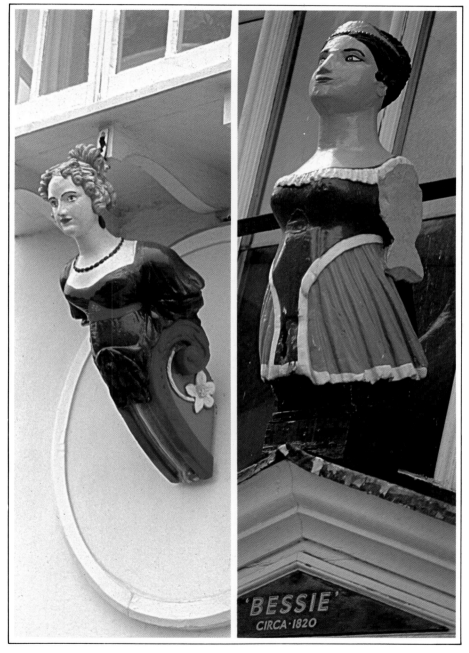

'BESSIE'
CIRCA·1820

Left: Figurehead from a ship built at Kristiansand, Norway. Until recently she could be seen in Pilgrim's Lane, Hampstead, London, her original white-and-gold colors gaudily painted over; but she has now been returned to Norway for safe-keeping.
Right: "Bessie", dated 1820, above a shop-front in
Market Road at Rye in Sussex, England.

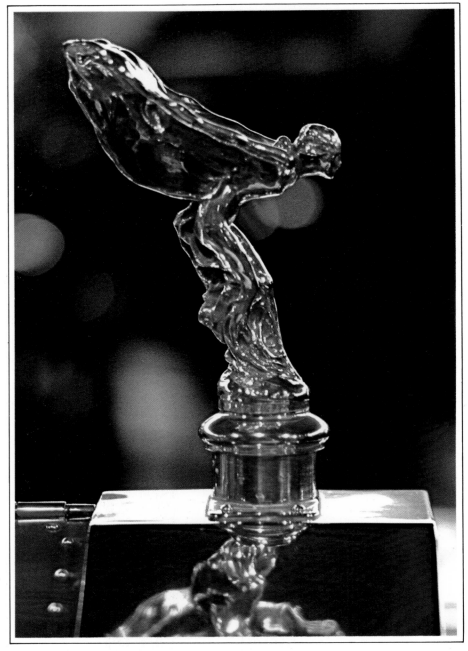

Rolls-Royce's mascot, "The Spirit of Ecstasy", was designed in 1911 by Charles Sykes at the request of Claude Johnson, the company's first managing director. Sykes' model is romantically believed to have been Eleanor Thornton – no stranger to Rolls since she had once been Johnson's secretary and was for thirteen years the mistress of Lord Montagu, a leading figure in early motoring. She died in 1915, while accompanying Montagu to India, when their ship was torpedoed in the Mediterranean.

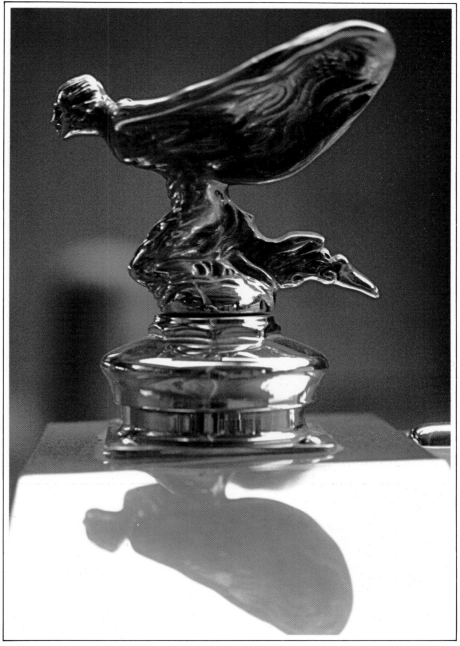

Today's more streamlined "Spirit of Ecstasy" (nicknamed the "Flying Lady"), was one of many variations introduced for different models of the car. Until 1939, production was supervised by Sykes or his daughter; the figures were variously cast in white metal, nickel and bronze, then silver-, chromium- or even gold-plated, and hand-finished, each bearing the date of registration and Sykes' signature. Rolls-Royce took over production in 1948 and mascots are now precision-cast in stainless steel.

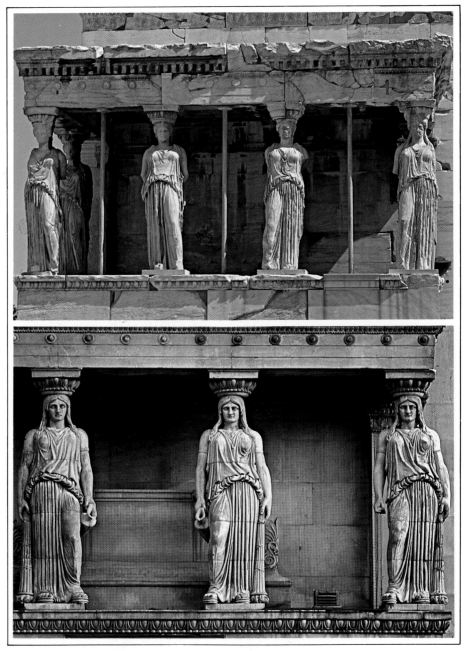

Top: The stone caryatids of the Erectheum, built in the fifth century BC on the Acropolis in Athens. They have inspired innumerable imitations. *Bottom:* The caryatids of the Parish Church of St Pancras in Euston Road, London NW1, built by H. W. and W. Inwood in neo-Grecian style in 1819, are faithful copies – save for the restoration of lost arms. They were sculpted by Rossi in terracotta on a cast-iron core.

—COLUMNS OF WOMEN—

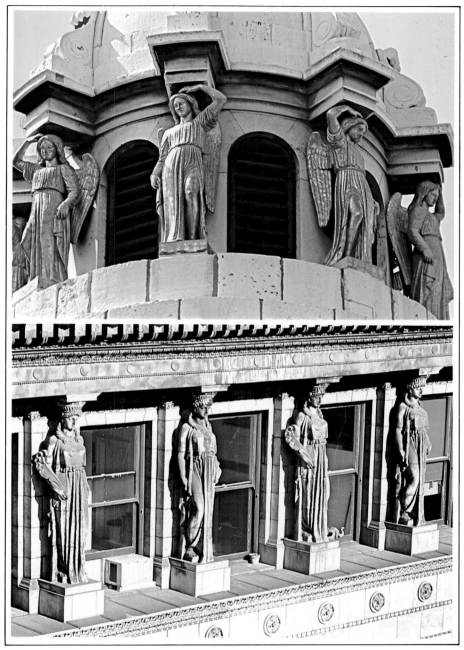

Top: Golden, winged caryatids holding up the elaborate stone cupola of St Mary's on Marylebone Road, London NW1, a Greek Revival church built by Thomas Hardwicke in 1813. *Bottom:* Stone caryatids on the twelfth floor supporting the roof of the Camelot Building, an office block on West 28th Street in New York.

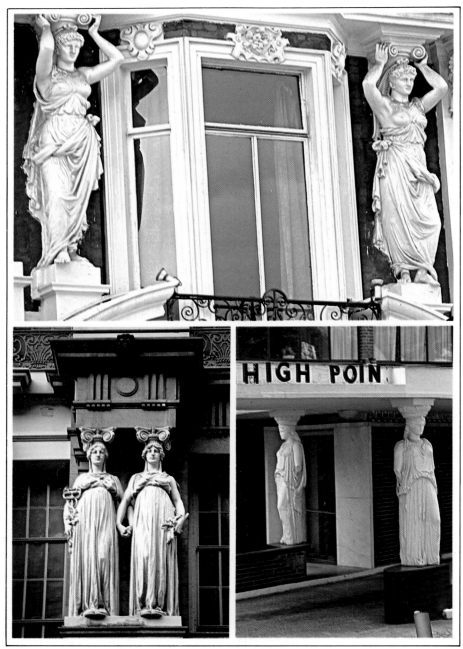

From left to right, top to bottom: Paired caryatids. Painted white on the facade of the White Lion pub in Putney High Street, London SW15, built in 1887; with hands entwined beside the clock at Macy's, the New York department store, built in 1901; copies of those at the Erectheum in an unfamiliar setting, on an austere 1936 apartment block, Highpoint, in London N6 – the architect, Lubetkin, added them to shock the Modernists, who decried such references to the past.

—SUPPORTING CAST—

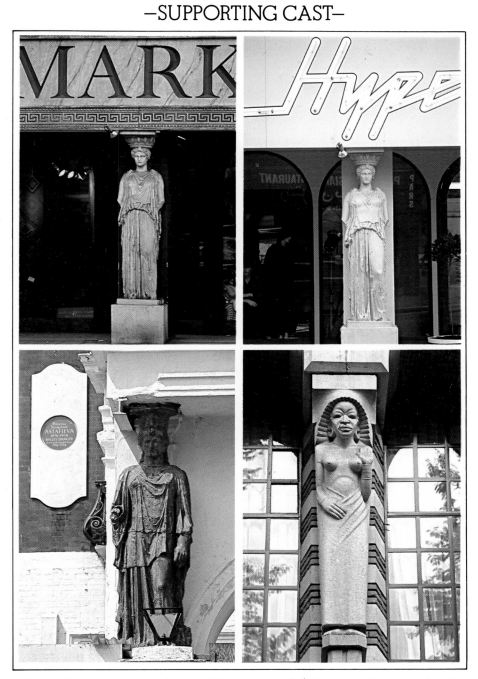

From left to right, top to bottom: Single caryatids. Grecian style, on the façade designed for an antique market in Kensington High Street, London W8, during the late 1960s; painted shocking pink when the same building became a fashion hypermarket; pastiche of the French style, on the portico of The Pheasantry in the King's Road, London SW3; in the bold 1920s style of the Amsterdam School, on the American Hotel in Amsterdam.

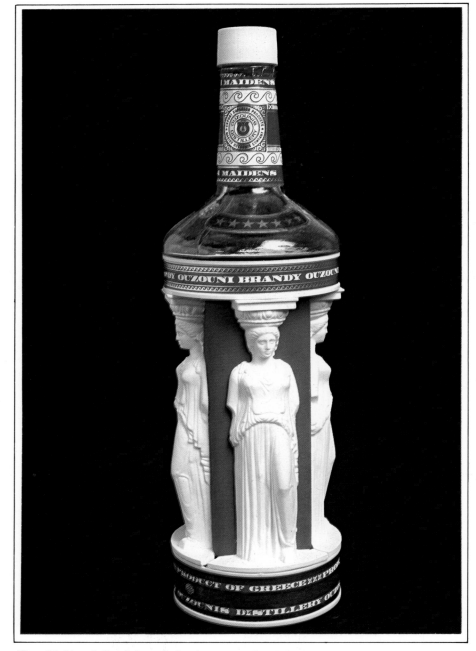

"Four Maidens" Greek brandy bottle, yet another imitation of the national heroines on the Acropolis – who incidentally leave little space for the brandy!

–GLASSY MAIDENS–

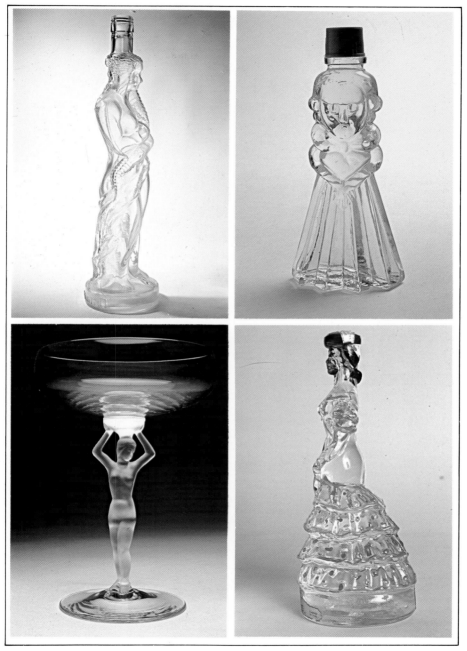

From left to right, top to bottom: Italian decanter, used for the traditional colored sweet liqueurs, in the shape of a naked lady draped with a serpent; perfume bottle, from Greece; champagne glass inspired by Lalique; anise liqueur bottle from Spain (the Señorita's hat is a cleverly disguised stopper and the ribbon decoration is the tax stamp).

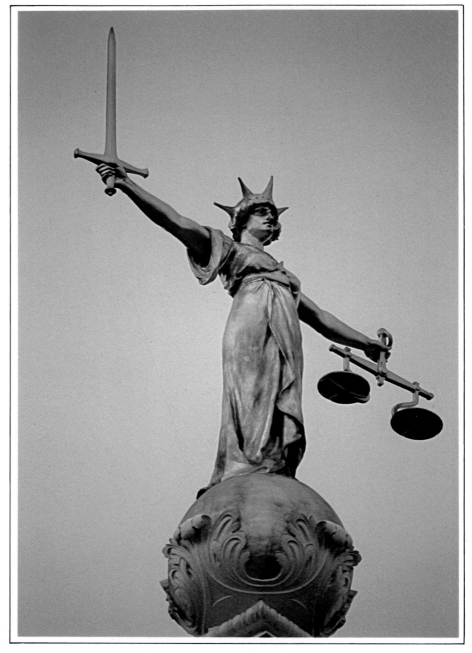

The bronze figure of "Justice", symbolically mounted over London's Central Criminal Court, the Old Bailey. Her sword and scales represent justice, her blindfold impartiality. Sculpted by F. W. Pomeroy, she is 16 feet high and stands 212 feet above the street. The Old Bailey itself was built in 1900 in a high neo-Baroque style, fitting for the great imperial capital London then was.

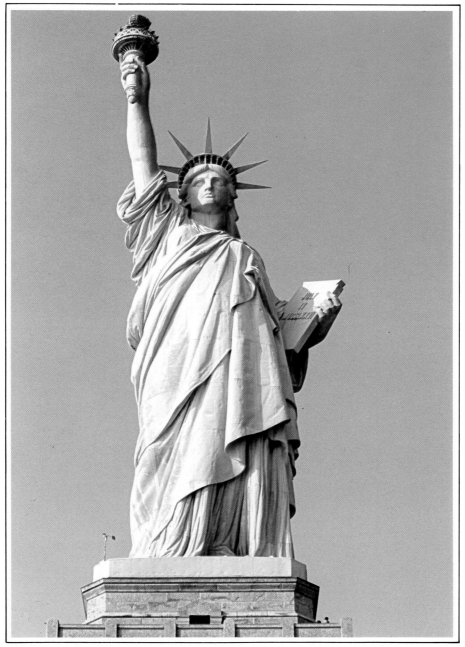

"Liberty Enlightening the World" in New York harbor. Since 1886, this colossal figure, more than 151 feet tall, has welcomed newcomers to America, bearing the torch of freedom and the tablets of the Declaration of Independence. Conceived by Auguste Bartholdi (originally as "Progress" for the entrance of the Suez Canal), with an interior steel structure designed by Gustave Eiffel, and cast in France, she was a gift to the American nation from the French.

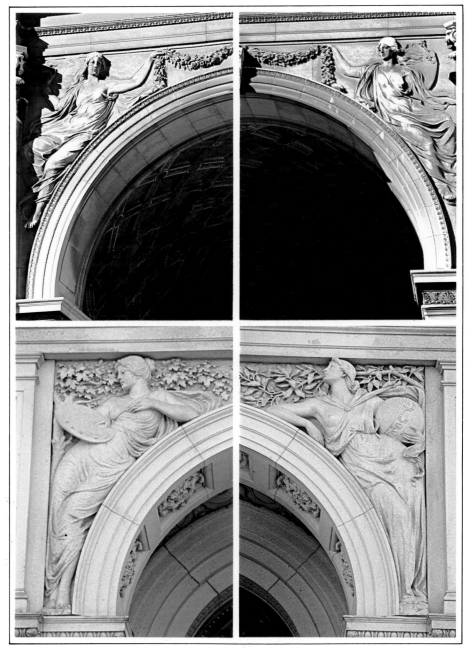

Top: Classical women holding garlands above the carved archway into the splendid courtyard of the Apthorp building in New York, built for the Astors in 1908. *Bottom:* Allegorical figures representing Painting and Science in the spandrels of the doors of the Library of Congress in Washington DC, built in 1889.

−CONSOLING WOMEN−

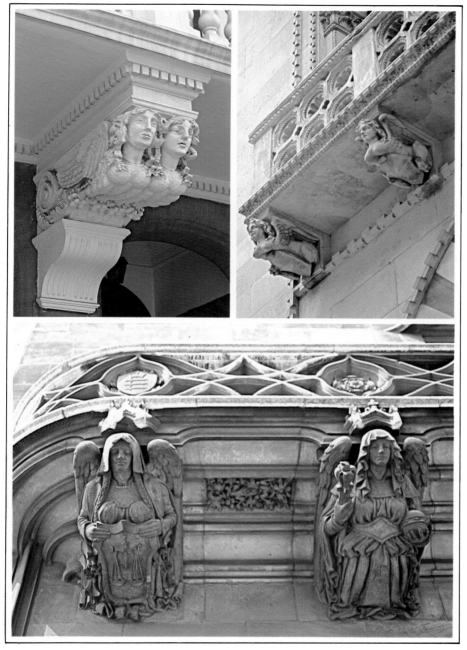

Top left: Extravagant console – or ornamental bracket – beneath a balcony in Pont Street, London SW1. *Top right:* Chimerical consoles, part bird, part beast, part woman, on an office building in Lothbury, London EC2. *Bottom:* Angelic consoles on the neo-Gothic Middlesex Guildhall in Parliament Square, London SW1, sculpted by Henry C. Fehr.

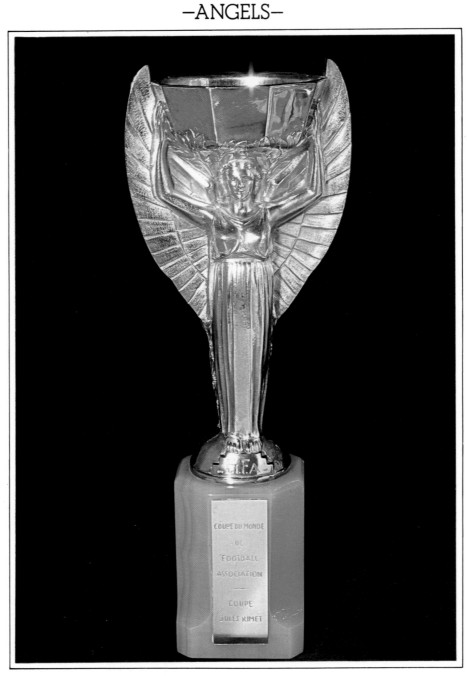

The footballer's dream: the Jules Rimet trophy presented to World Cup winners, named after the Honorary President of the International Football Association when the championship tournament was founded in 1930. The original cup was won outright by Brazil at their third victory in 1970, and stolen in 1983. This is the replica presented to England after their victory in 1966.

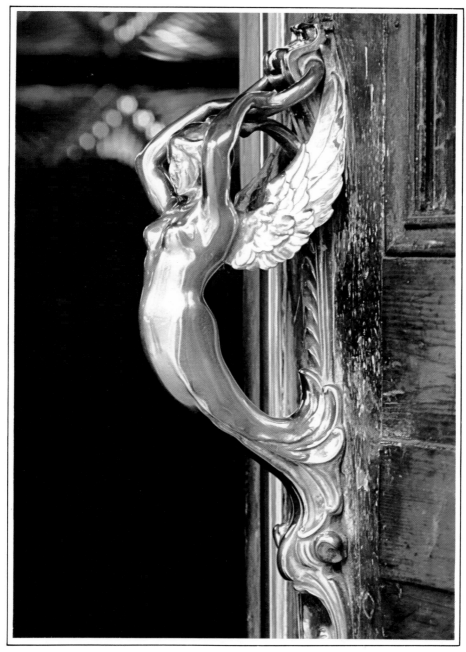

Sleek angel on the front door of Maxwell's Plum, the restaurant and bar on 1st Avenue and 64th Street, New York. Constant handling keeps her well polished.

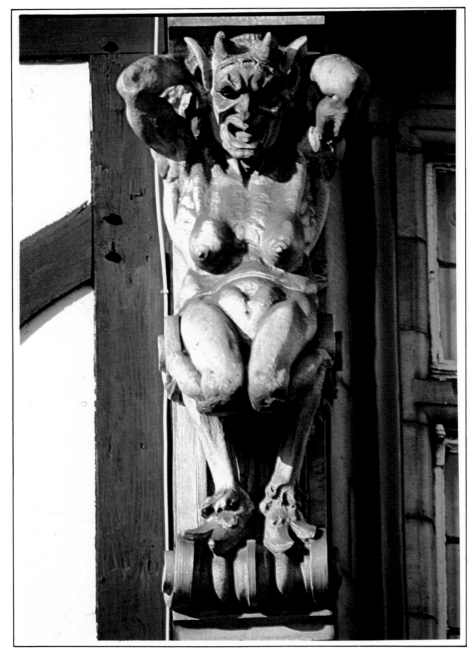

Grotesque female demon with cloven feet supporting the eaves of the mock Tudor pub, the Grand Junction Arms in Praed Street, London W2. The publican maintains that she watches over traffic on the Grand Union Canal, which runs opposite the pub.

—WITCHES—

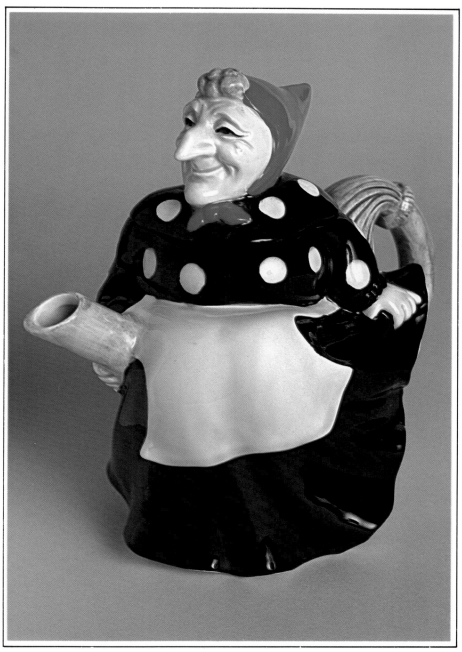

Wicked witch riding a broomstick, a contemporary teapot. It is skilfully contrived so that the broomstick forms the spout, and the head of the broom is part of the handle.
Made in America by Fitz and Floyd.

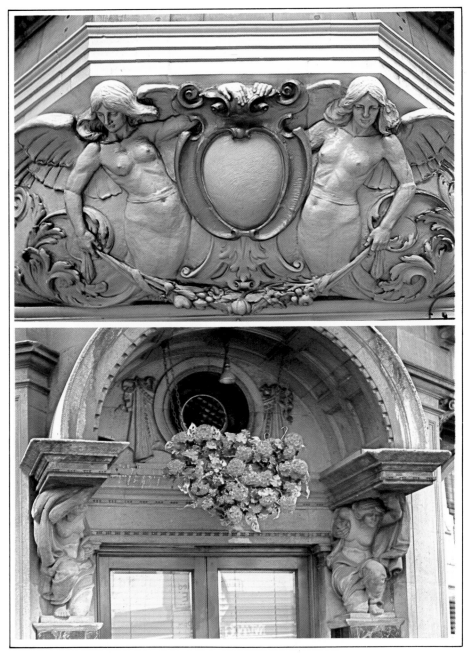

Top: Painted stone figures holding a shield, on the corner of Cosmo Place and Southampton Row, London WC1, probably once an imposing entrance to the Grand Hotel.
Bottom: Kneeling women struggling under the weight of the portico at Cobb's, a London butcher. The shop, in Sloane Street, SW1, was built for Cobb's in 1905.

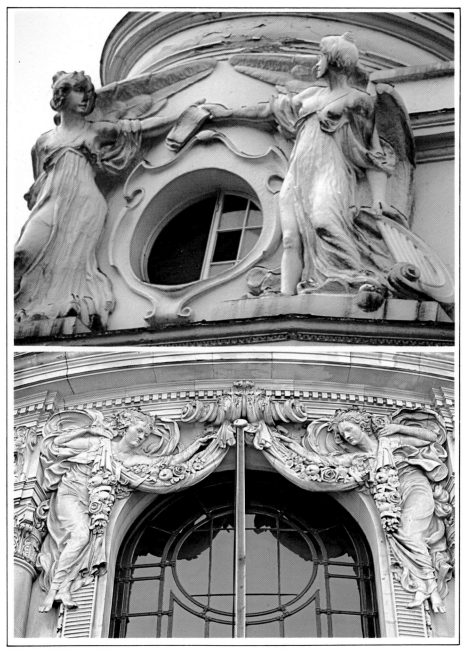

Top: Massive stone angels framing a porthole beneath the dome of London's Apollo Theatre, built in 1900. *Bottom:* Surprisingly frivolous French-style figures decorating the Methodist Central Hall in Westminster, London, built in 1905.

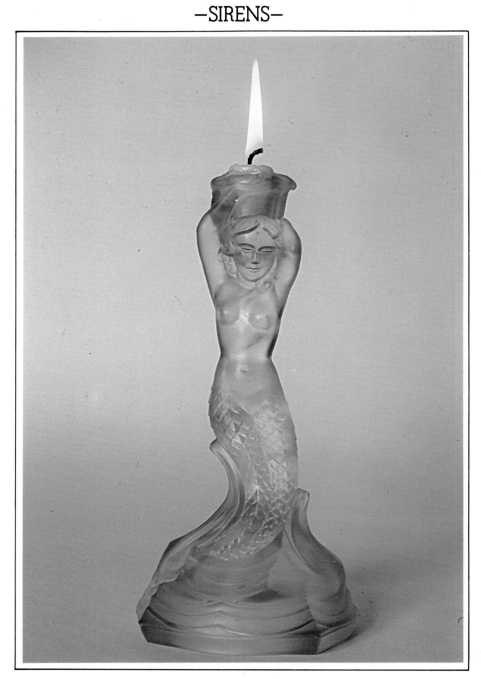

A siren capriciously bearing a light — her attractions were a legendary danger to men at sea. 1930s candlestick molded in opalescent glass.

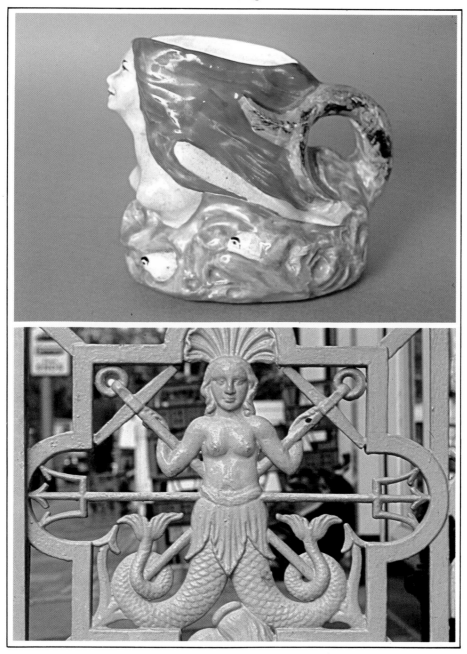

Top: A playful mermaid's curling tail forming the handle to a small jug made by Westminster of Hanley, Staffordshire, England. *Bottom:* Double-tailed mermaid, entwined with anchors and tridents, giving a maritime theme to a cast-iron balustrade at 5 Pont Street, London SW1.

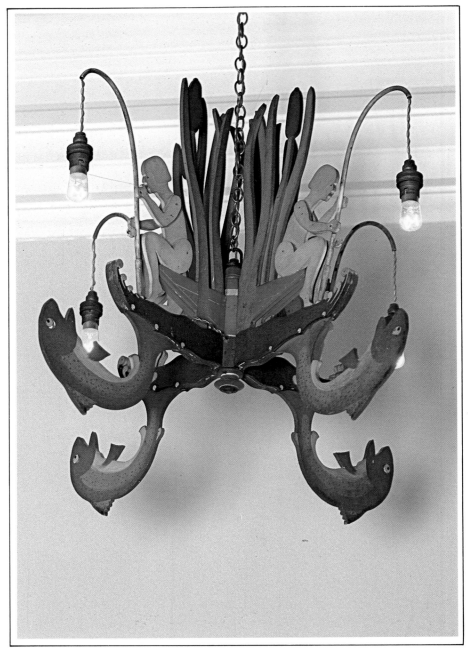

Painted wooden chandelier from the nursery of the former Viceroy's House in New Delhi, designed, down to the light fittings, by Sir Edwin Lutyens in 1931. The girls lure fish with light-bulbs dangling from their rods!

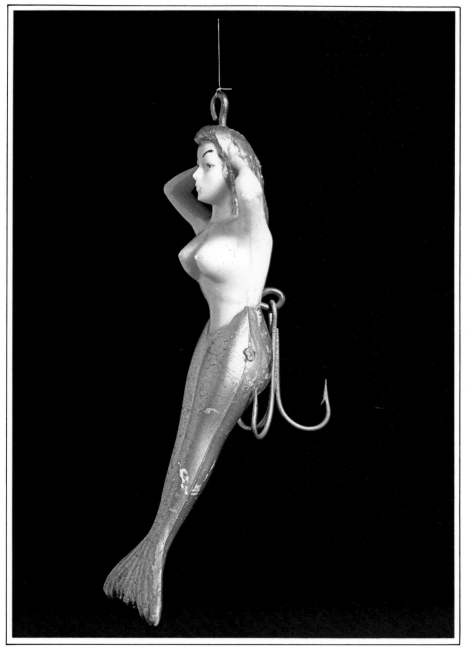

Fish-hook with weighted mermaid as lure – to attract the fish? Metal and plastic,
made in America in the 1950s.

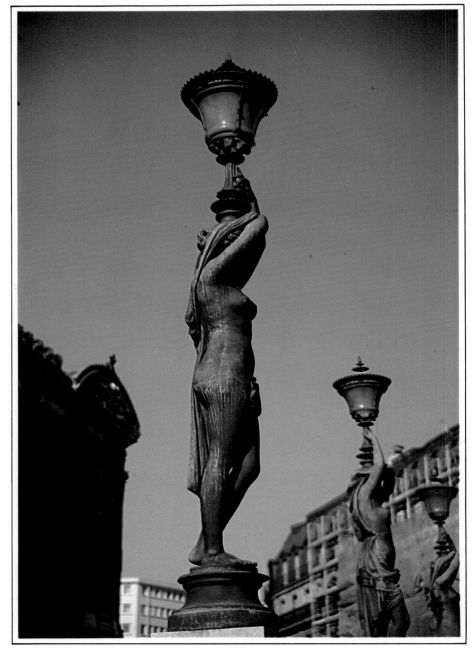

Larger-than-life bronze figures lighting the concourse outside the Paris Opéra,
sculpted by Thomas, 1875. The extravagant design of the lamp-posts is in keeping
with the opulence of Charles Garnier's opera house,
which was completed the same year.

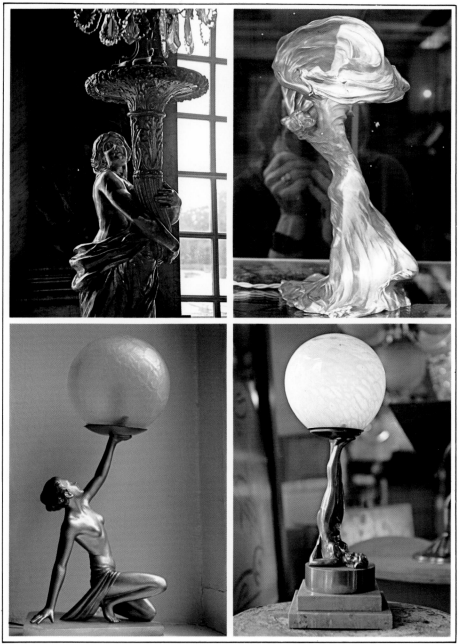

From left to right, top to bottom: Life-size gilded figure holding a crystal chandelier in the Galerie des Glaces at Versailles, France; bronze Art Nouveau lamp sculpted by Raoul Larche, the light source concealed by billowing robes; French Art Deco bronzed lamp-bearer with glass globe; acrobat balancing a ball in a reproduction of a 1930s French lamp.

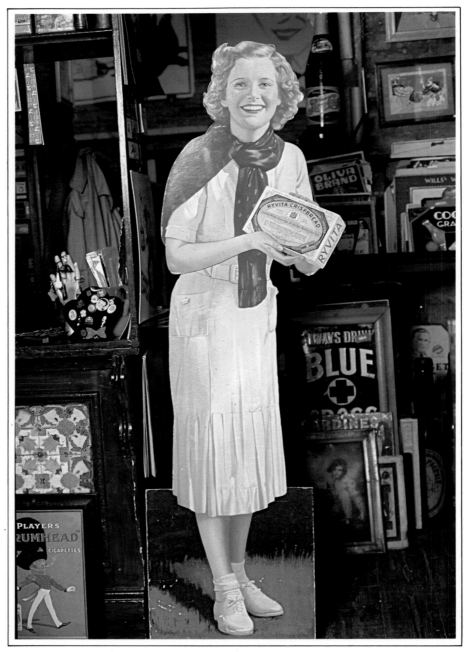

Ryvita girl, designed by Edwin Byatt in 1934. Her fresh, outdoor looks emphasized the health value of this famous brand of crispbread.

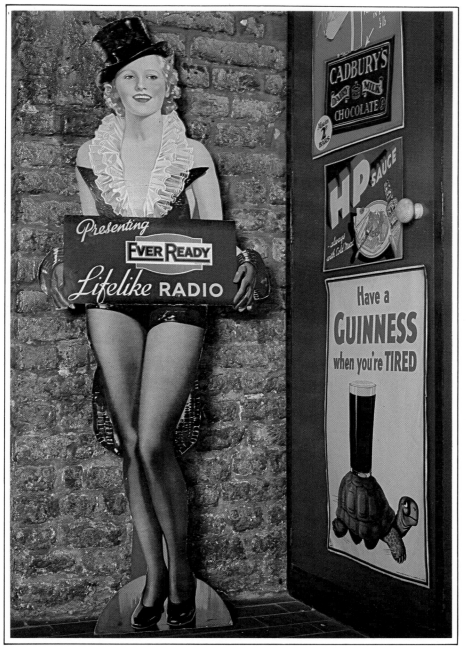

Bringing some glamour into a man's world, the Ever-Ready batteries showgirl,
designed in 1937 by Louis Johnstone.

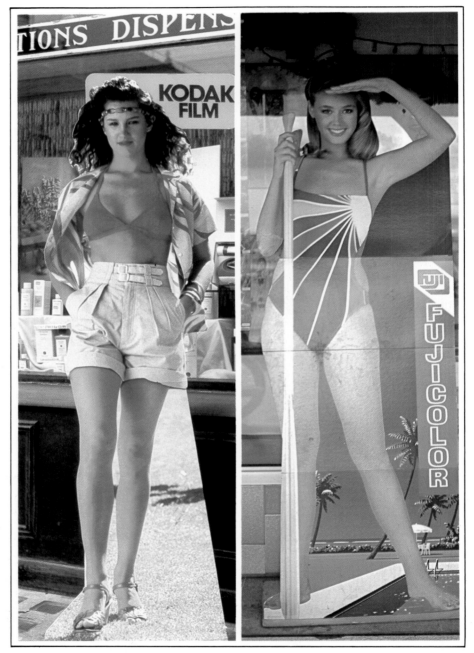

Left: Kodak girl, 1984 vintage. Kodak's founder, George Eastman, used girls to advertise his camera film from 1890 onwards, and the company's first cut-out film girls took to the streets in the 1920s. Today every camera-film company seems to have one. *Right:* Japanese Fujicolor girl in Kuantan, Malaysia.

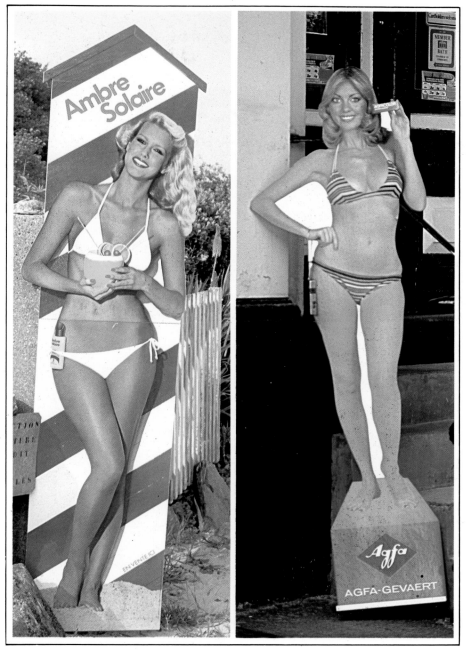

Left: Bronzed beauty advertising Ambre Solaire suntan lotion on the dunes at Le Pouldu, Brittany, under a hot sun. *Right:* The Agfa girl seems out of her element on a wintry day in the town centre of Bath, England.

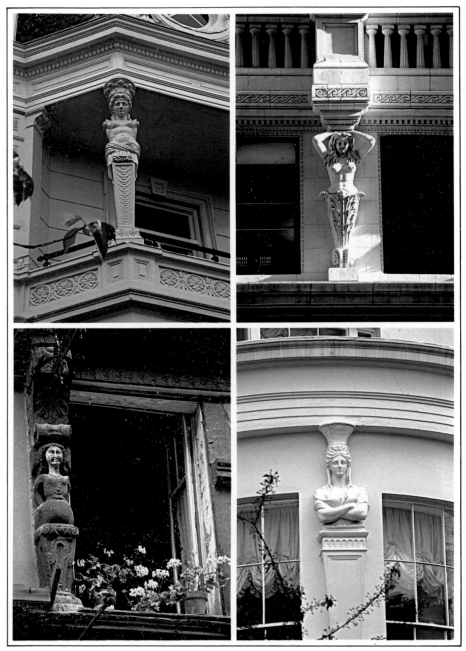

From left to right, top to bottom: Terms – tapering pillars that support a sculpted bust –
on a house at the corner of Jan Luykenstraat, Amsterdam; on an office block at 91st Street
and 5th Avenue, New York; on a timber-framed house in Rue Geoffroy de Pontblanc,
Lannion, Brittany; and on Cornwall Terrace, one of John Nash's terraces
at Regent's Park, London.

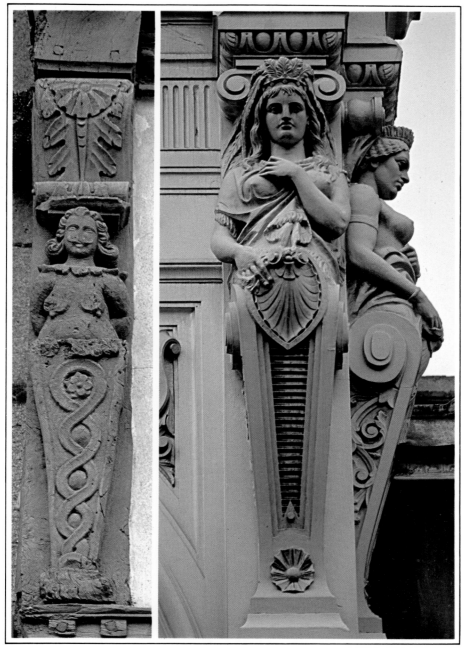

Left: Bizarre term on a fifteenth-century house in Place Général Leclerc, Lannion, Brittany – though sporting a moustache, the figure also has breasts! *Right:* Painted plaster pairs on the Victorian façade of the Royal Arcade, between Old Bond Street and Albemarle Street, London W1.

—HANDS THAT HOLD—

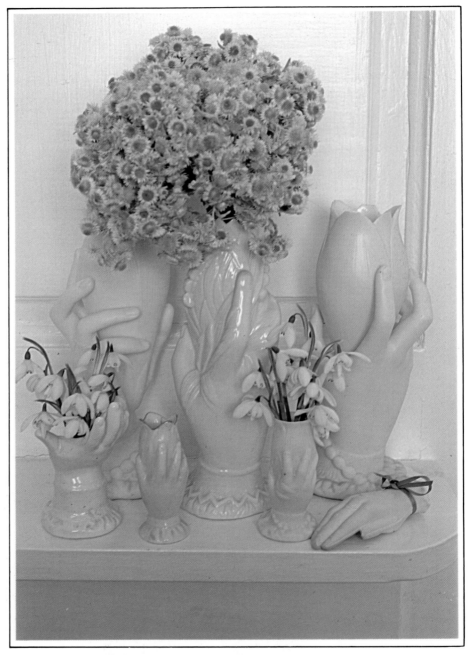

A collection of white ceramic hand vases: the larger ones are Victorian, the smaller ones have been produced over the last 100 years as souvenirs from British holiday resorts. There is also a cake of soap in the form of a beribboned hand.

–HANDS THAT HOLD–

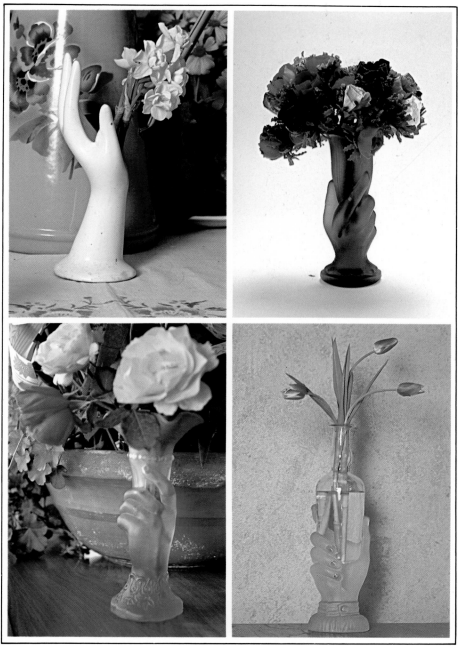

From left to right, top to bottom: White ceramic hand forming a vase; reproduction Bristol blue glass hand holding a vase; frosted glass hand holding a flounced vase; a simple frosted glass hand holding a clear bottle.

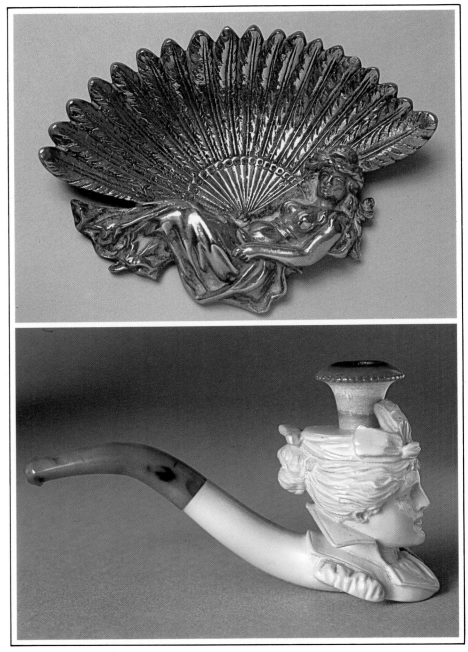

Top: Art Nouveau ashtray, made of brass, a reclining lady with a huge feather fan.
Bottom: Viennese meerschaum cheroot holder in the shape of a woman's head, circa
1870. The clay has been stained amber by nicotine over many years' use.

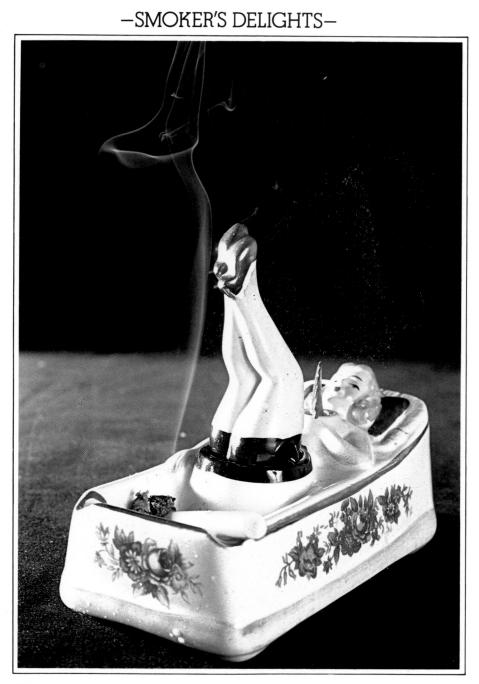

Kitsch ashtray with reclining lady who waves her fan and kicks her legs to disperse the smoke. By Sarsaparilla Deco Designs, Japan, 1979.

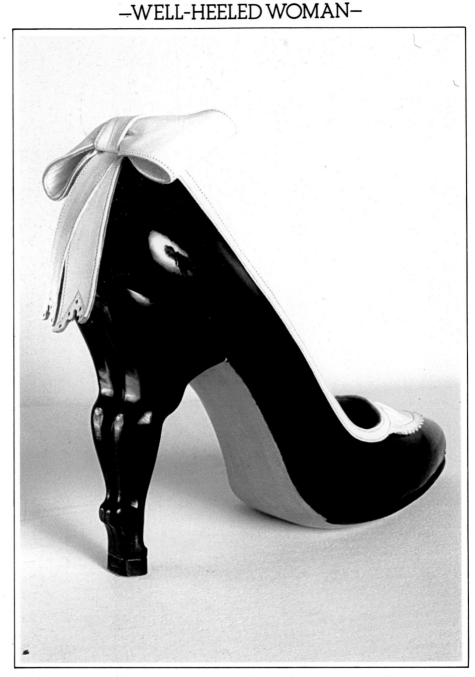

"La Bonne" shoe, designed and made by Thea Cadabra and James Rooke in 1980. Created as a joke on British nostalgia for the formal society of the past, it was inspired by the uniform of the waitresses known as "Nippies" at London's famous Lyon's Corner House, recently reopened in the Strand. The heel itself caricatures the stance of a woman in high heels. But the shoe is fully structured and intended to be worn.

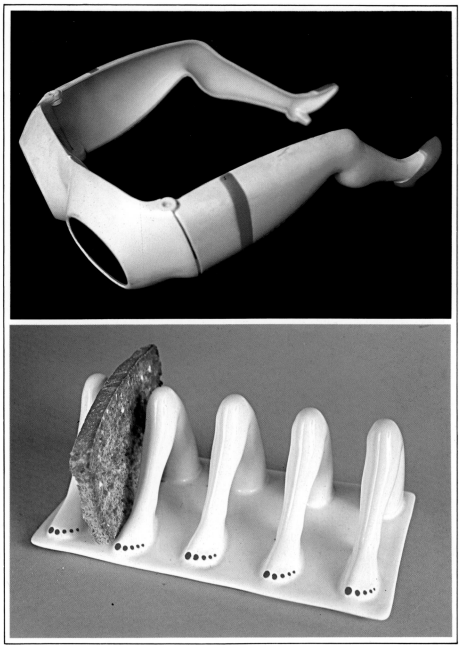

Top: Plastic sunglasses with head-gripping legs, provocatively called "Sin-glasses", made in Hong Kong in the 1960s. *Bottom:* Contemporary English toast-rack, a row of legs with painted toe-nails. Made by Carltonware.

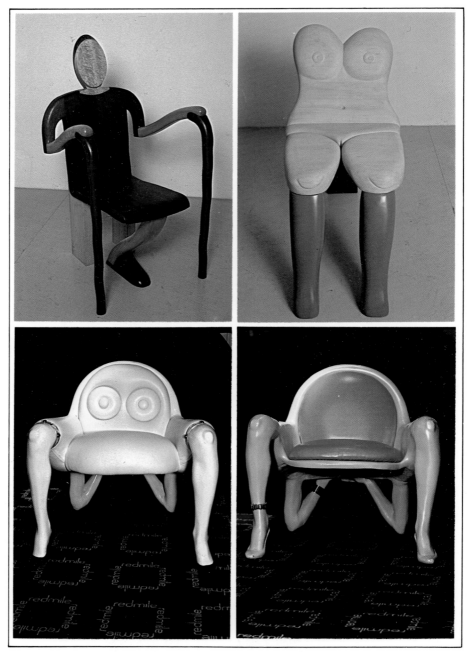

Top, from left to right: Two chairs by New York sculptor Alan Siegel. "Old Lady with Canes", 1981, hand-carved in four woods (maple, mahogany, black walnut and poplar) and joined with dowels; "Torso Chair", 1980, maple with polychrome decoration. *Bottom:* "Body Chair", from a 1930s design. Two variations, upholstered on a frame of cast fiber glass reproduced in London by Anthony Redmile.

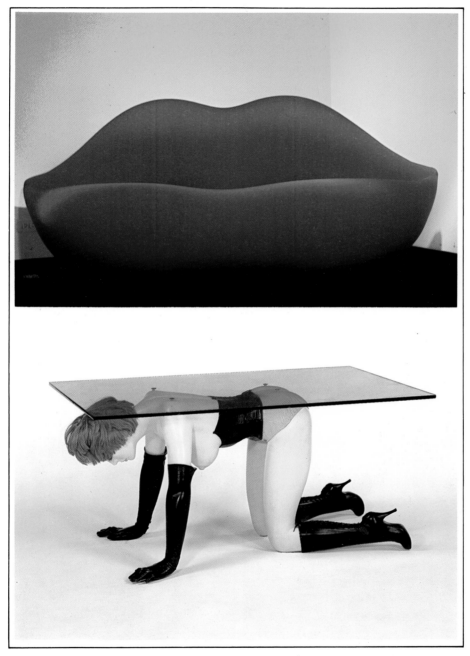

Top: Giant lips sofa aptly named "Marilyn" in the United States. Made of molded foam and red nylon fabric by Gufram in Italy. *Bottom:* Controversial coffee table by artist Allen Jones, one of a limited edition produced in London in 1969; the top rests on the back of a woman in fetishistic clothing and in a debasing position.

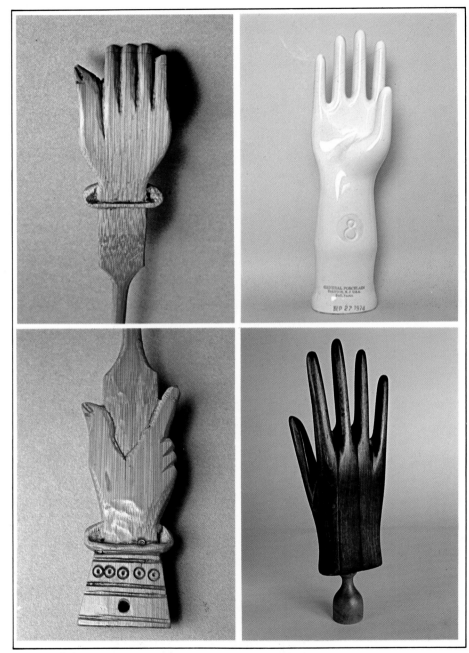

Top and bottom left: Tip and handle of a hand-carved Chinese back-scratcher. *Top right:* Rubber glove mold made by General Porcelain Company in the United States. *Bottom right:* Wooden stretcher for leather gloves. The hand slides apart in sections so that the glove can be removed when it has dried tight on the mold.

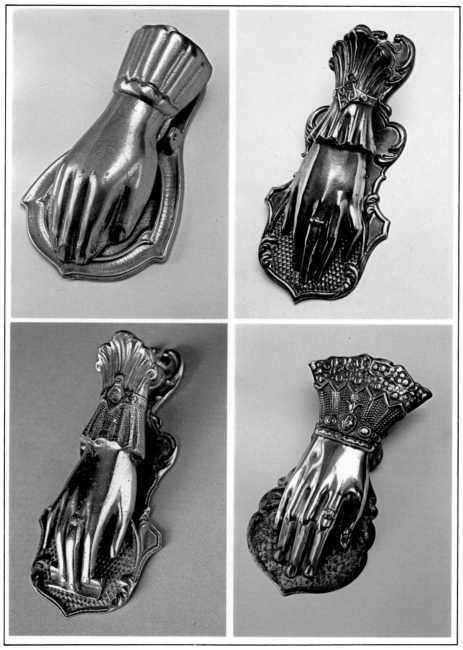

From left to right, top to bottom: English card-holders, made of brass, each with a spring to grip the cards. A very plain, lightweight 1930s design; a Victorian holder, made by J. B. Ratcliff of Birmingham (the maker's name and patent registration information are stamped in the diamond lozenge on the bracelet); and two other Victorian variations.

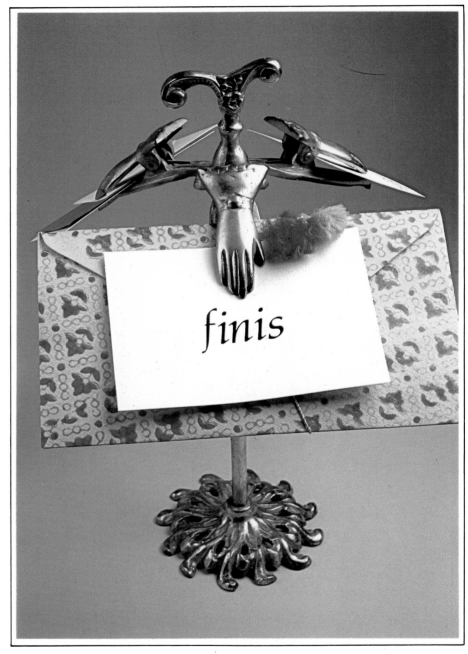

Contemporary brass reproduction of a Victorian desk tidy, made in India.

ACKNOWLEDGEMENTS

The following individuals and organizations kindly loaned or donated objects, gave permission to photograph, or otherwise helped to supply the illustrations for this book: *p. 1* (timesaver) Alan Fletcher; *p. 6* (cigar Indian) Adams Antiques, 53 Fulham High Street, London SW6; *p. 7* (biscuit) Claudia Florio; *p. 8* (chrome opener) Marla Dekker, (brass opener) Mr and Mrs Bernard Knight; *p. 9* (aluminium opener) Lorraine Johnson; *p. 10* (bullet opener) Rosie Oxley, (fairy opener) John Jesse and Irina Laski, 160 Kensington Church Street, London W8; *p. 11* (pen) Elizabeth Henderson; *pp. 12-13* (cocktail and swizzle sticks) Tim Oliver; *p. 16* (stove) Rose Gray and David McIlwaine, (bootjack) Pamela Barnett, 44 King's Highway North, Westport, Connecticut, USA; *p. 18* (Tudor housewife) Jill and Robert Slotover, (Victorian lady) Squirrels, Cinqueport Street, Rye, Sussex, England, (Dutch girl) Yolande Pals; *p. 19* (pier table copy) Victoria and Albert Museum, London; *p. 20* (cocktail sticks) Anthea Davies; *p. 21* (Jayne Mansfield) Dagmar d'Offay; *p. 22* (nail-clippers) Joyce Scotland, (teapot) Judy Lever, (pyjama-case) Josephine Oliver; *p. 23* (bottle doorstop) Daisy Mendoza, (candlestick) Angelika Eggebrecht, (doll doorstop) Lore Breitbarth, (moneybox) Lu Jeffery; *p. 24* (pewter candlestick) John Jesse and Irina Laski; *p. 25* (ceramic candlestick) Jenefer Phillips; *pp. 26-7* (clasps, rings, brooches and pendants) Elizabeth Henderson; *p. 32* ("beehive" cruet) Judy Lever; *p. 33* (waitress cruet) Rosie Oxley, Brian and Brenda Palmer; *p. 35* (chicorée) Christian and Florence Ficat, (Droste's cacao) Pieter and Annette Brattinga; *p. 36* (betel-nut cutter) Henrietta Green; *p. 38* (callipers) Lou Klein; *p. 39* (bottle opener, penknife and toothbrush) Barry Weaver, (nail-file) Jean and Kati Robert; *pp. 40-41* (collection of brushes) Lou Klein; *p. 42* (double egg cosy) Theo Crosby; *p. 43* (embroidered and knitted cosies) Elizabeth Farrow at Dodo, near Portobello Road, London W11, (silk-screened cosy) Cuckoobird Ltd, Tonbridge, Kent, England (designed by Pat Albeck); *p. 44* (naked lady and farmer's wife teapots) Graham & Green, Elgin Crescent, London W11, (Victorian lady teapot) The Tea House, Neal Street, London WC2, ("Daintee Laydee") Miki van Zwanenberg (farmer's wife and Victorian lady teapots designed by Tony Wood); *p. 45* (golf tee) Tony Ramsden; *p. 49* (Parisian caryatids) photograph Lorraine Johnson; *p. 50* (pixie box) John Jesse and Irina Laski, (powder box) Elizabeth Farrow at Dodo, (shell lamp) Graham & Green; *p. 51* (atomizing lamp) John Jesse and Irina Laski; *p. 52 (Cutty Sark)* National Maritime Museum, Greenwich, London, SE10; *p. 54* (Rolls-Royce mascot) Beaulieu Motor Museum, Hampshire, England; *p. 60* (brandy bottle) Matthew Wrigley; *p. 61* (Italian decanter) Alan and Paola Fletcher, (perfume bottle) Henrietta Green, (champagne glass) Michael and Julie Joseph, (anise bottle) Marianne Ford; *p. 66* (World Cup) The Football Association, London; *p. 69* (witch teapot) Judy Lever; *p. 72* (siren candlestick) Vida Doris Brockbank; *p. 74* (chandelier) Viscount Ridley; *p. 75* (fish-hook) Louis Zona Sr.; *p. 76* (Opéra lamp-post) photograph Lorraine Johnson; *p. 77* (Versailles lamp) photograph Lorraine Johnson, (Art Nouveau lamp) Victor Arwas, Editions Graphiques Gallery, 3 Clifford Street, London W1, (Art Deco lamp) Jenefer Phillips; *pp. 78-9* (Ryvita and Ever-Ready girls) Elizabeth Farrow at Dodo (originally printed by James Haworth Ltd, Leicester, England); *p. 80* (Kodak girl) Kodak Ltd; *p. 84* (white ceramic vases) Elizabeth Henderson; *p. 85* (white hand) Elizabeth Farrow at Dodo, (hand with clear bottle) Alan and Paola Fletcher; *p. 86* (brass ashtray) Rosie Oxley, (cheroot holder) Leo Breitbarth, (leg ashtray) Henrietta Green; *p. 88* ("La Bonne") Thea Cadabra and James Rooke; *p. 89* (sunglasses and toast-rack) Barry Weaver; *p. 90* ("Old Lady" and "Torso" chairs) Alan Siegel, c/o Nancy Hoffman Gallery, 429 West Broadway, New York, ("Body Chairs") Anthony Redmile, 95 Pimlico Road, London SW1; *p. 91* (sofa) Stendig, New York, a subsidiary of Stendig International Inc, (table) photograph Sotheby Parke Bernet & Co, London; *p. 92* (back-scratcher) Lorraine Johnson, (rubber glove mould) Elizabeth Henderson, (glove stretcher) Paola Fletcher); *p. 93* (Ratcliff holder) Marianne Ford, (three other holders) Elizabeth Henderson; *p. 94* (desk tidy) Jill and Robert Slotover.

Most of the other small objects photographed are in the collection of Jessica Strang.

Author's Acknowledgements
Most special thanks to Pentagram and all its partners, who opened my eyes, and to all those friends and associates over the years who have told me about weird and wonderful places or objects to add to my collections, and given me help and information, especially: Tim, Josephine and Orlando Oliver, Ambassador and Mrs. Zain-Azraai, Bruce and Emmy Davidson, Barbara Kulicke, Elizabeth Burney Jones, Anna Pugh, John Ashurst, Peter Lee, Sophia Schachter, Nesta Roberts, Kaspar Schmid, Frances Jowell and Sarah Lister.

I would also like to thank the authors of the following works, which proved invaluable: James M. Goode, *Outdoor Sculpture of Washington D.C,* Smithsonian Institute publication; Stephen Jacoby, *Architectural Sculpture in New York City*, Dover; Nikolaus Pevsner, *The Buildings of England: London*, Penguin.

All the photographs were taken with Nikon equipment on Kodak Ektachrome film, and processed by Debbie Wells at Sky Processing, London.

Lastly, I would like to thank Lorraine Johnson, who turned an idea into a book.